PERSISTENCE OF VISION

Photographs by DAVID LUBBERS

FOR ELIZABETH

PERSISTENCE OF VISION

Photographs copyright ©2000 David Lubbers
All rights reserved

Published 2000 by Wm. B. Eerdmans Publishing Company
255 Jefferson S.E., Grand Rapids, Michigan 49503/
P.O. Box 163, Cambridge CB3 9PU U.K.

Editor: Mary Hietbrink
Book design: Walt Matzke

Library of Congress Cataloging-in-Publication Data

Lubbers, David, 1947-
Persistence of Vision / by David Lubbers.
p. cm.
ISBN 0-8028-3884-7 (hardcover : alk. paper)
1. Landscape photography--United States. 2. Lubbers, David, 1947-
I. Title
TR660.5L85 1999
779'.36'092--dc21

PERSISTENCE OF VISION

Photographs by DAVID LUBBERS

WILLIAM B. EERDMANS PUBLISHING COMPANY

GRAND RAPIDS, MI / CAMBRIDGE, U.K.

PREFACE

I've always been a visual person. In elementary school, I found myself looking out the windows. The rectangular glass panes of the schoolroom were uneven, and distorted straight lines into wavy lines. They transformed power lines and tree branches into abstract patterns. By moving my head just slightly, I could change the composition—and entertain myself. In college, I was still making compositions with windows. Years later, I realized I was using the ground glass of my view camera in the same way, selecting rectangles just like I had when I was a child. The window was still there.

I never think much about what I choose to photograph. The process is intuitive: I respond to what I see.

When I actually sat down to reflect on my motivation, it occurred to me that two key factors shape my work. One is time or timeliness. It is fascinating to me that with a camera, in a fraction of a second, I can arrest a subject that has been developing for years. The conditions as much as the subject determine whether the scene has possibilities. I might be tempted to photograph a scene when I first see it, but then I wonder about what would make the scene more visually interesting—long shadows, a layer of fog, a blanket of snow. I always look at something several times, waiting for the moment when it best reveals itself. Optimum timing is crucial.

The other element is relationship or relatedness. We are frequently asked to see the differences in situations or places. Our tendency is to separate and divide rather than cooperate and combine. Differentiation is best in many contexts. But I prefer harmony and compatibility in the photographs I take. I want the viewer to easily make visual connections between the elements in each photograph and thus recognize their value to the overall composition. It's that kind of relatedness of elements that makes a photograph inviting.

Relatedness, in fact, is what connects the photographs in this book. That wasn't the motif I had in mind when I took these photographs; it's the one that developed while I was choosing them. As I laid out the first group of photographs I had selected, I realized that some went well with others. Soon I was looking for more companions to photographs I wanted to include. I began putting them together in pairs.

Some pairs looked remarkably similar even though they were photographs of areas that were far apart geographically. Some had the same ambience or feeling even though their subjects were different. Still other photographs were linked by a common element.

Next I put the pairs in a sequence that read well. I noticed that in this order, they fell loosely into three categories—trees and water, rocks and desert, and people and architecture. To make the transitions smoother, I added a few photographs. At this point I had an order I liked, but I was still missing a unifying theme.

Suddenly it dawned on me. Subconsciously I had arranged the photographs in a way that reflected life's cycle. Birth and beauty lead to questioning and struggle, which in turn lead to contemplation, eventual death, and beyond. The correlation was a bit of a stretch, but the photographs told the story. The play, the dialogue between them added another dimension.

I had begun by wondering what photographs to include, and why. I had arrived at a selection and an order that were telling a story without words. Like looking out a window.

DAVID LUBBERS
Grand Rapids, 1999

A POETIC VISION

The first photograph I ever saw David Lubbers take was in the winter of 1981 alongside the Merced River. We were en route to our destination, Yosemite Valley, and the indescribable beauty I knew lay there. I recall the experience because it afforded such a lucid insight into what makes his art and the man himself so distinctive. A few miles short of the valley proper, David abruptly pulled the car off to the side of the road and began unpacking his camera equipment. Anticipating the divine grandeur that was about to unfold just up the road, I remember privately wondering what on earth he was doing. As he set up for a shot, I discovered his subject was a frosting of newly fallen snow on the gnarled, interwoven roots of two ancient sugar pines across the water. Like a grandmother's praying hands beneath a veil of white lace, this image, once identified, was entrancing. Still, I was astounded that David had spied it from our moving vehicle. And it wasn't, quite frankly, the subject matter I'd envisioned when David had expressed a desire to photograph Yosemite. He clearly must have read my thoughts, for in between glances at the patchwork of clouds overhead, he quietly said, "If it's a shot worth taking in Yosemite Valley, you know Ansel Adams has already done it in each of the four seasons at six different times of the day, right? I guess I'm trying to do something else."

This comment typifies the man and his work. He has never been much interested in the grandiose statement or that eye-popping buena vista that can stir the soul with its high drama. Perhaps that's why he's shied away from shooting in color as well. Even though I'd probably describe him as principally a landscape photographer, any examination of his work reveals the fact that the landscapes, objects, and people captured by his lens are no more important than the purity of a line, the sublime grace of a curved form, and the nuances of shadow and light that happen to catch his eye.

This collection of photographs from places around the world—some radiant, others subtly understated and often almost demure—aren't intent on dazzling the eye. They ask more of us: an act of imagination, our unhurried contemplation. As such, David's images speak to a part of our humanity given short shrift these days—a quiet soulfulness, a tranquility of spirit. In so doing, they seem to transcend the boundaries of place and time. In a manner reminiscent of the haiku poems of an old Zen master, David's photographs have a marvelous ability to capture the elusive but inherent natural beauty of the single moment that too often lies hidden beneath the fabric of our everyday lives.

Let me stretch the poetry metaphor just a little further. This book's format, in which select photographs are presented in pairs, recalls an age-old word game that Japanese poets indulged in with each other. The first poet would write a three-line haiku verse, intending to explore or express some universal theme through the use of simple, natural images. He would then share this haiku with another poet, whose task it became to add two additional seven-syllable lines, yielding a five-line verse called "tanka." The two new lines were intended to complement the original haiku, and their design could be to echo or expand upon, bend or even playfully satirize the spirit or essence of the initial three-line verse. The end product was often a delightful nexus, an imaginative co-mingling of perception and response that somehow transcended the sum of its dual parts. The imagery of these poetic forms was often symbolic of one of the four seasons, and the poets' vision, insights, and musings often focused on one of the different "seasons" or stages of an individual life.

With all that in mind, I was struck by how the pairs of photographs displayed in this book—some linked visually, others conceptually—seem to embody the same kind of playful yet profound dynamic found in Japanese tanka poems. David's dual images rejoice in recognition of the exquisite beauty and lyrical grace that abide in seemingly commonplace contexts the world over. As a collection, these photographs are arranged in a way that seems to suggest a progression through life's seasons. Individually and collectively, these luminous images invite more than just viewing. They invite our meditation, our affirmation. They are evocative not only because they are so captivating, but also because they pay homage to our spiritual link to the natural world, which is our greatest gift, and to our fellowman, with whom we must learn how to share it. In so doing, these photographic pairs showcase an important part of David Lubbers's enduring significance as an artist.

PHIL ASAKAWA

David Lubbers and I first crossed paths twenty years ago, when he took a counseling job at the California public school where I teach. We discovered that we had a range of common interests, and we became fast friends, kindred spirits. During the fledgling stages of his life as a photographer, I had the opportunity to accompany David on numerous photo "expeditions," from trying to time surging waves over craggy moonscapes at Salt Point on the northern California coast to slogging through miles of Paria Canyon mud in search of lost Anasazi dreams. Despite the persistence of our folly, David somehow always managed to find and capture moments of breathtaking beauty, an ability I found nothing short of miraculous. During the last decade, I've admired from afar the evolution and refinement of his work, both behind the camera and in the darkroom. This book bears ample proof of that.

imprinted memory of similar subjects. Seeing photographs in pairs, as the viewer is invited to do here, provides a valuable way to study a body of work, not only because it suggests comparisons but also because it makes clear the transparent line which runs through all photographs that are the result of persistent vision, no matter what their subject may be. I always look for consistency and the "transparent line" in the work of photographers who bring me their prints to consider. In the beginning of our relationship, David would arrive on my doorstep, typically in the spring, with cases of photographs (usually 16" x 20" in format) all mounted, overmatted, and ready for presentation—all the product of the previous year's work. For a long time, the West remained a favorite subject, but slowly I began to see the results of his increasing trips to Mexico. It was evident that the basic elements of form and structure that could be found in David's photographs made in the canyonlands of Utah were repeated in his architectural studies of abandoned buildings in Oaxaca and Pátzcuaro. The line running through his work was clear.

As he became more well-known as an artist, David was invited to exhibit outside of the United States; he took his work as far as Italy and Latvia. Of course he always photographed in these locations, adding layer upon layer to his experience. He also experimented with different processes, printing in platinum and overseeing the production of hand-pulled photogravures, an almost lost printmaking art once used extensively by photographers such as Alfred Stieglitz and Paul Strand. Ultimately, David and I published two limited-edition portfolios together, one in platinum and one in photogravure, both focusing on his work in Mexico.

Over the years, we have had wide-ranging conversations about all things related to the "state of the art." At some point we discussed the curious fact that many photographers will travel great lengths to make pictures while overlooking the beauty that can be found in their own backyard. Taking this to heart, David began working more in Michigan, and I am pleased to see the number of superb images, made close to home, that appear in this book. As valid as these photographs are, however, they still illustrate that the strength of the

work lies not in its identity by location but in the persistence of the vision. Two good examples are "Cross Village, Michigan" (pl. 25) and "Cape Sebastian, California" (pl. 26). There are numerous others.

An interesting recurring theme in David's recent work is the inclusion of people. His "street portraits," by current definition, are considered environmental, always including elements of the subjects' surroundings. But much like his other photographs, they are quiet and respectful, as evidenced by "Oudega, Netherlands" (pl. 63) and "Oaxaca, Mexico" (pl. 64). Given this new direction, it didn't come as a surprise when David called me recently to say that he was headed to Cuba—not to have an adventurous vacation but simply to work. It is my feeling that the photographs he made there on his first trip, many of which include the human figure, represent some of the most elegant images he has made to date. In these photographs I can identify all of the elements of style that David has developed over two decades—chiefly, a respect for form, the careful composition that more often than not uses vertical lines to divide spatial planes, and the democratic division of black-and-white tones that rarely allows one to dominate over the other. I am also reminded of something that Minor White once said about one of his own images: "While rocks were photographed, the subject is not rocks; while symbols seem to appear, they are only pointers to significance. The real meaning appears in the space between the images; in the mood it raises in the beholder." On the occasion of the publication of this book, I trust that the meaning and significance of David Lubbers's work will become as evident to those who see it as it has long been to me.

JON BURRIS

Jon Burris has been a photographer, a curator, a fine-art dealer, and a publisher. He was director of photography for the National Cowboy Hall of Fame and Western Heritage Center, Oklahoma City, and is currently director of the Brett Weston Archive, Oklahoma City. He is also on the advisory boards of numerous museums in Oklahoma and is president of Portfolio, Inc., a fine-art consulting company.

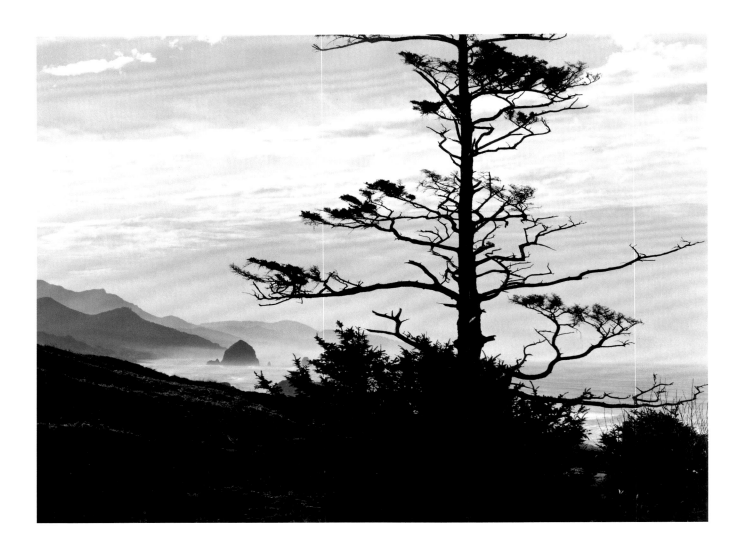

CANNON BEACH, OREGON 1997

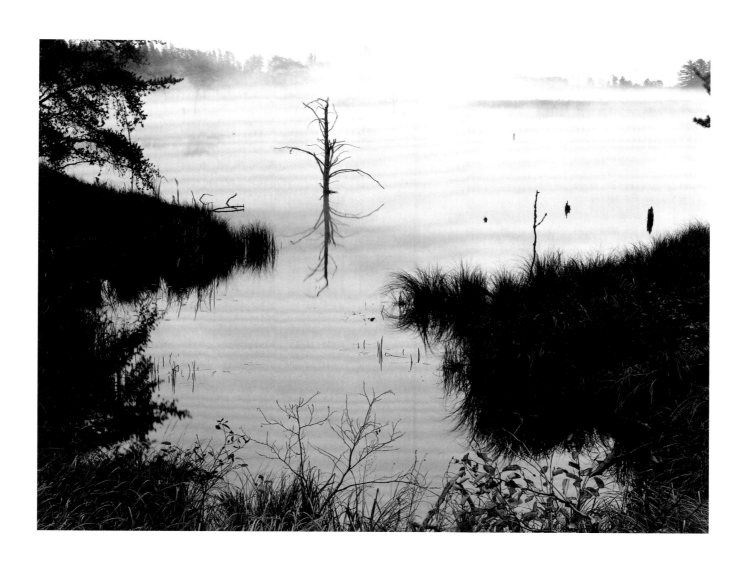

SENEY, MICHIGAN 1997

3

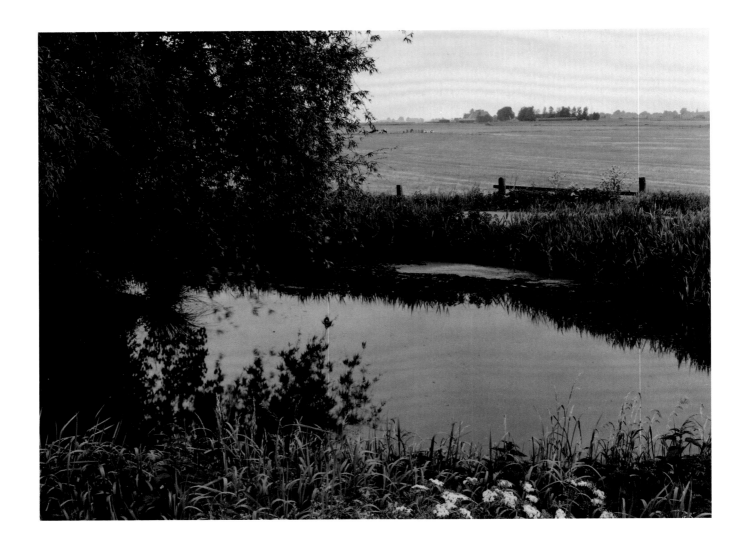

WORKUM, NETHERLANDS 1998

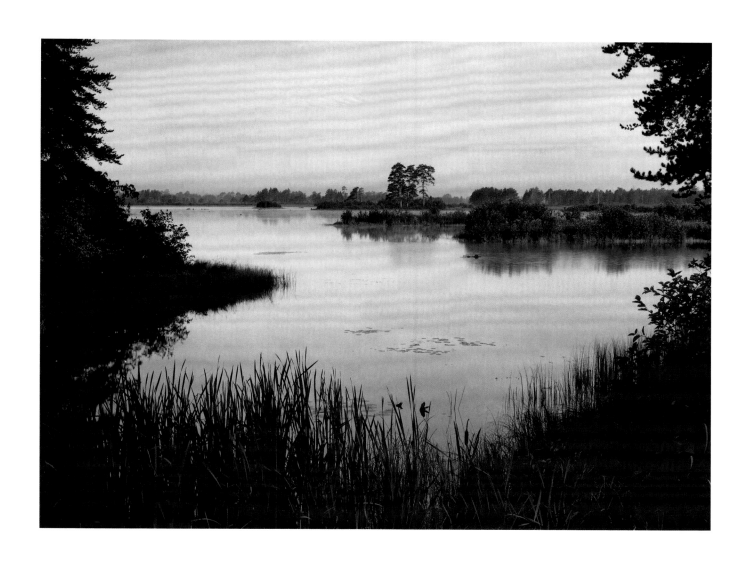

SENEY, MICHIGAN 1995

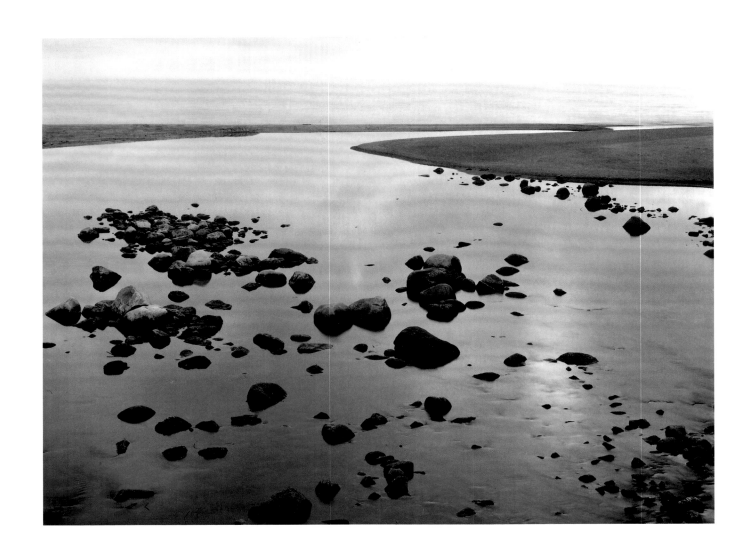

WAWA, CANADA 1995

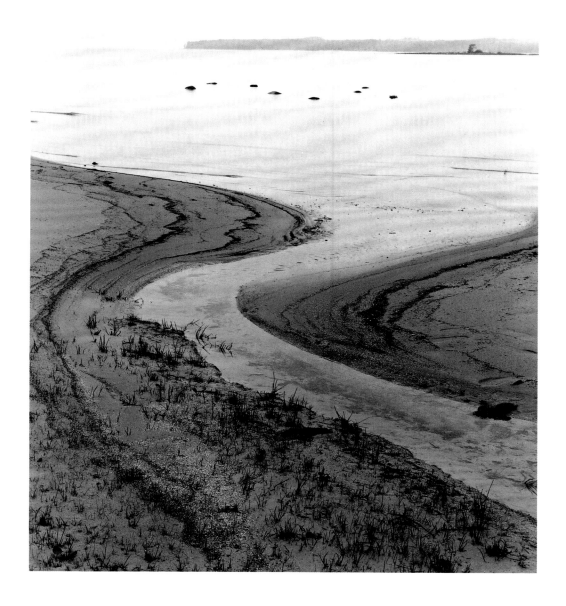

EPOUFETTE, MICHIGAN 1991

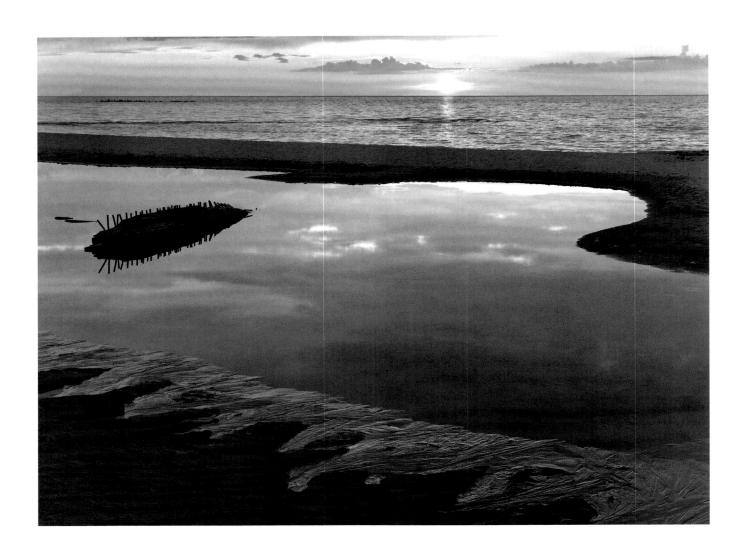

CROSS VILLAGE, MICHIGAN 1987

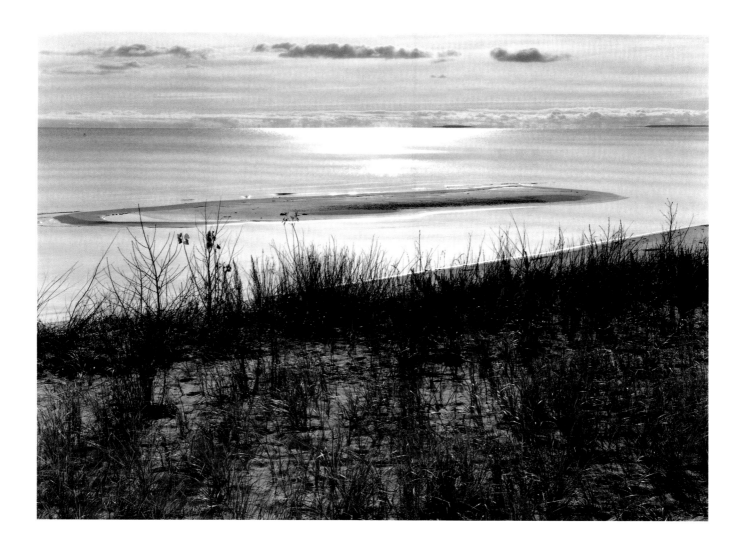

ESCANABA, MICHIGAN 1994

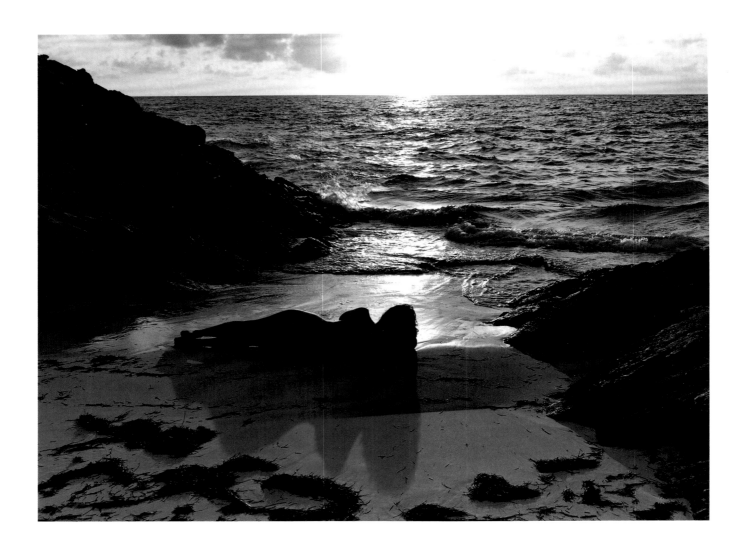

ELEUTHERA, BAHAMAS 1992

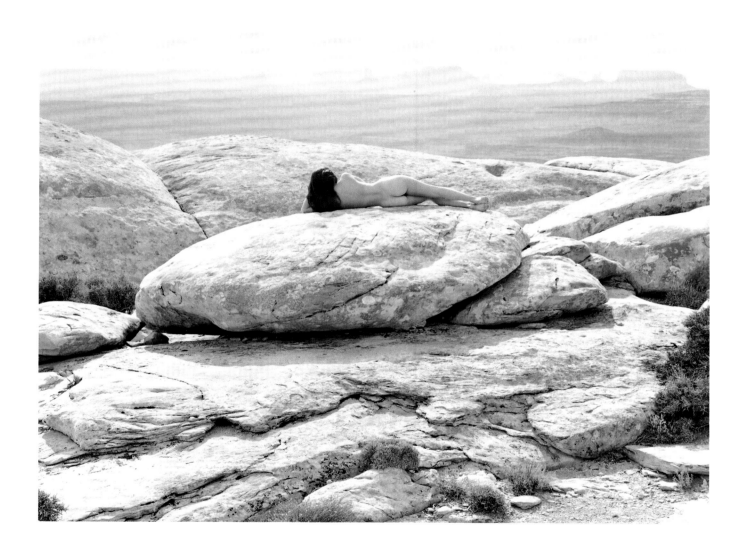

MULEY POINT, UTAH 1984

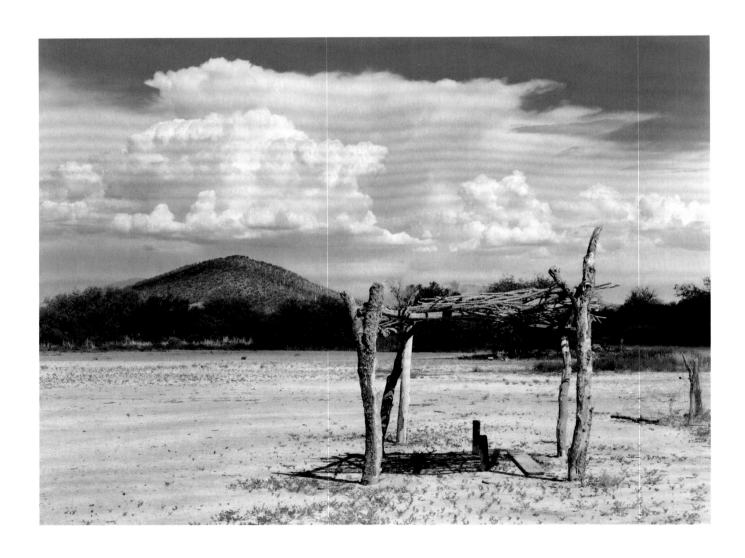

SAN XAVIER, ARIZONA 1987

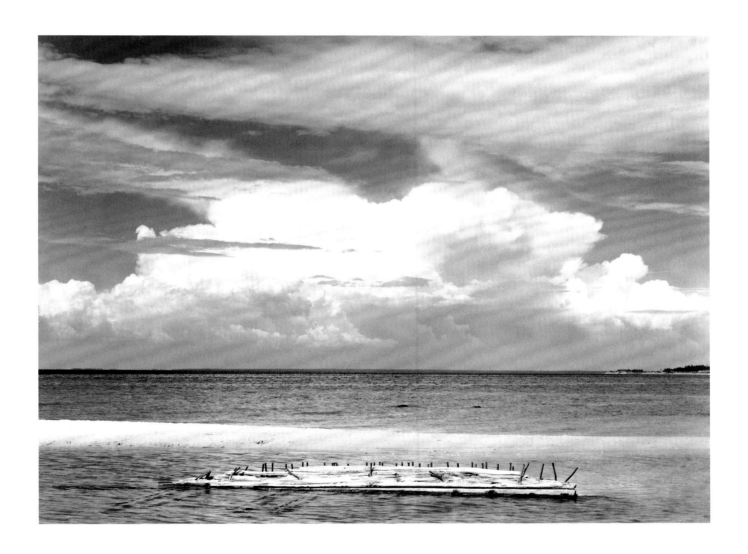

CROSS VILLAGE, MICHIGAN 1991

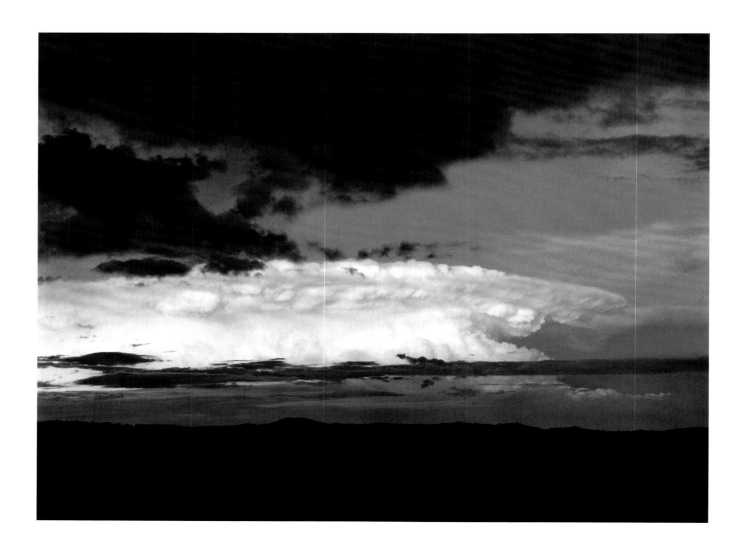

CRIPPLE CREEK, COLORADO 1989

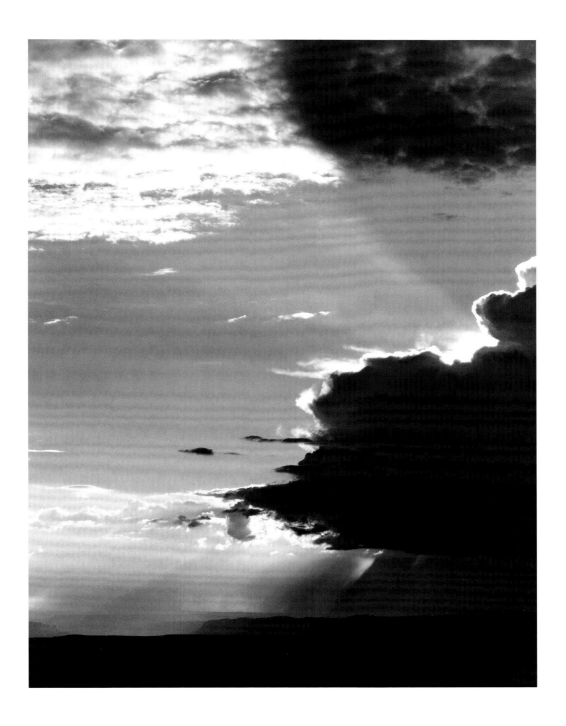

MULEY POINT, UTAH 1991

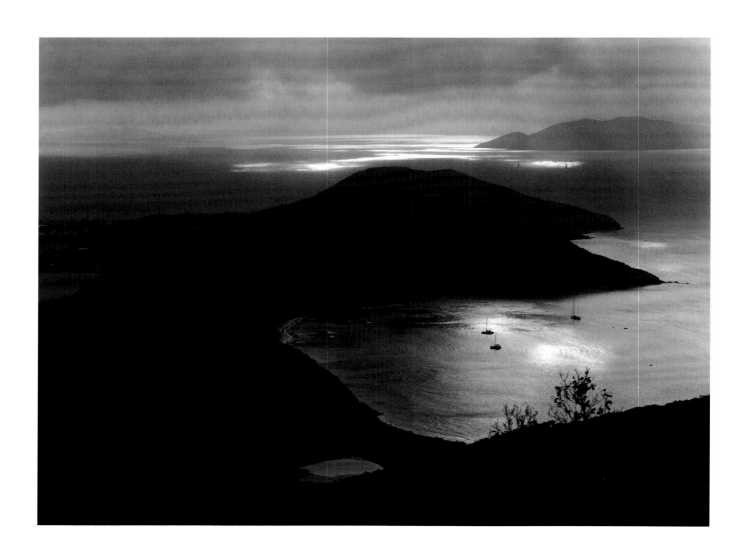

VIRGIN GORDA, BRITISH VIRGIN ISLANDS 1998

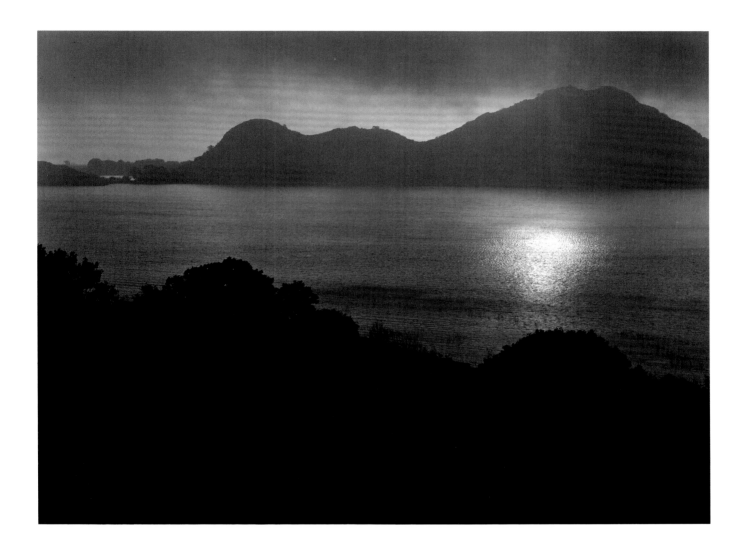

QUARTZ MOUNTAIN, OKLAHOMA 1987

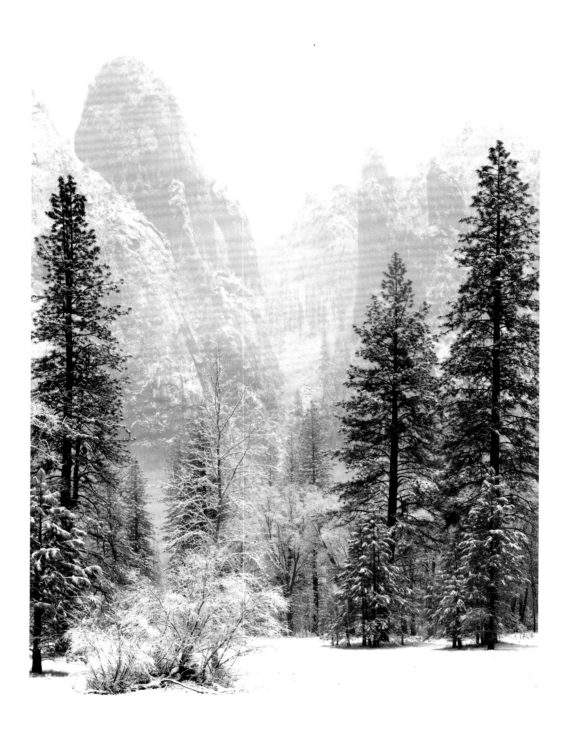

YOSEMITE VALLEY, CALIFORNIA 1995

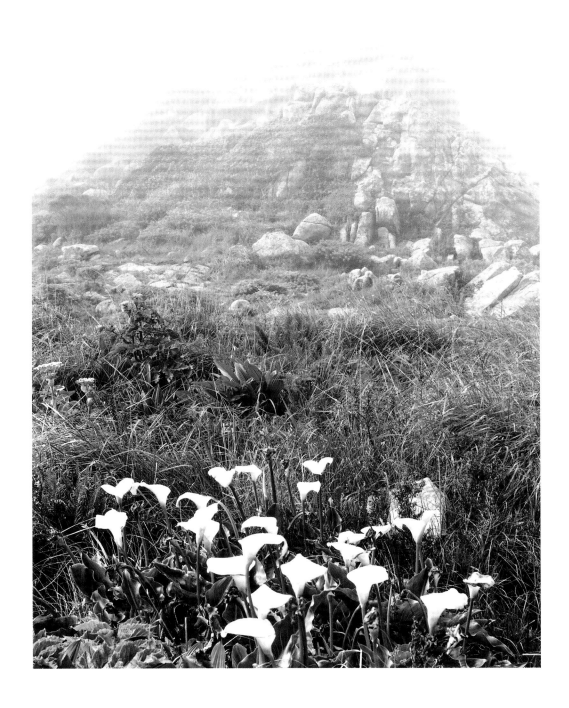

SALT POINT, CALIFORNIA 1984

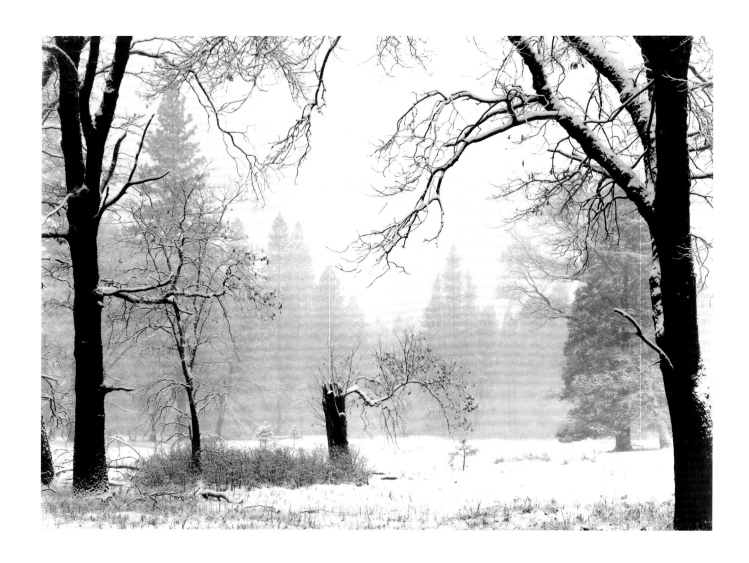

YOSEMITE VALLEY, CALIFORNIA 1991

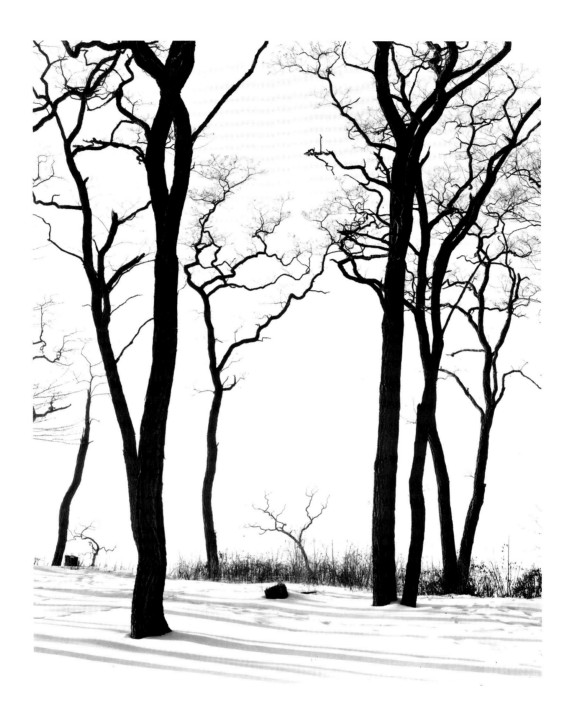

DOUGLAS, MICHIGAN 1996

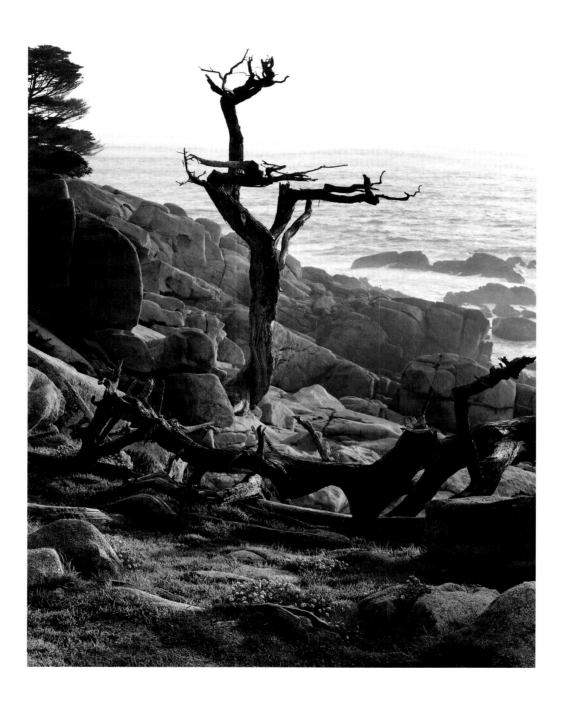

CARMEL, CALIFORNIA 1996

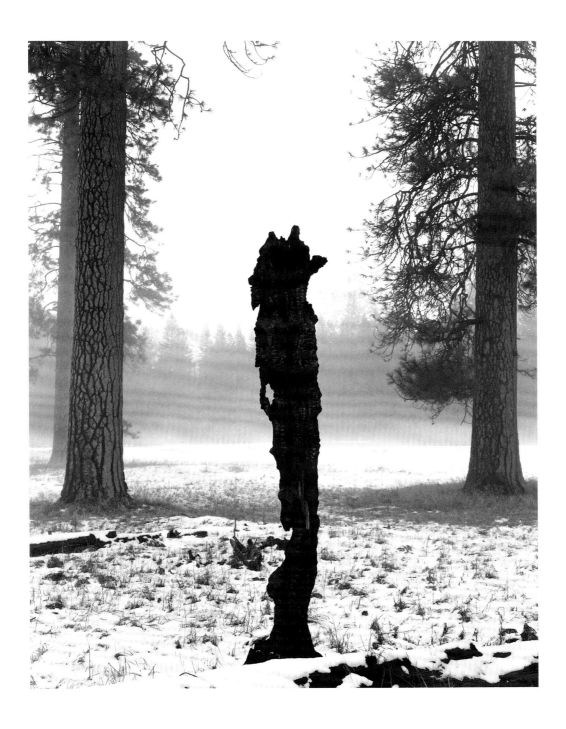

YOSEMITE VALLEY, CALIFORNIA 1991

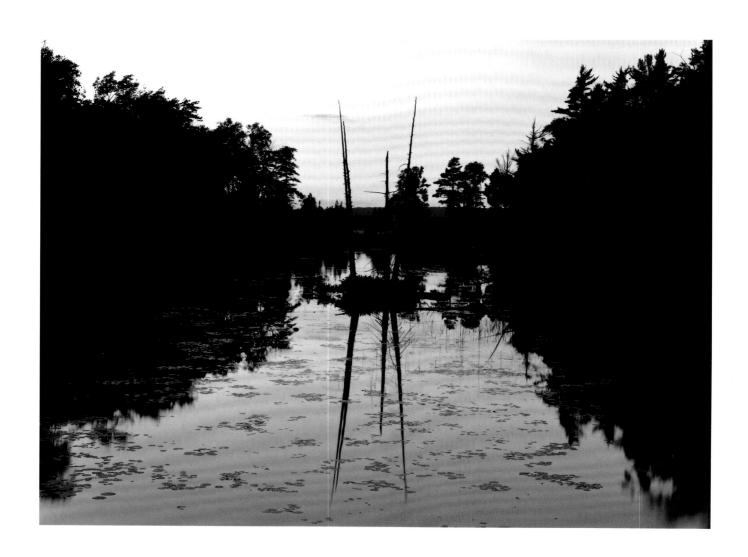

COPPER HARBOR, MICHIGAN 1994

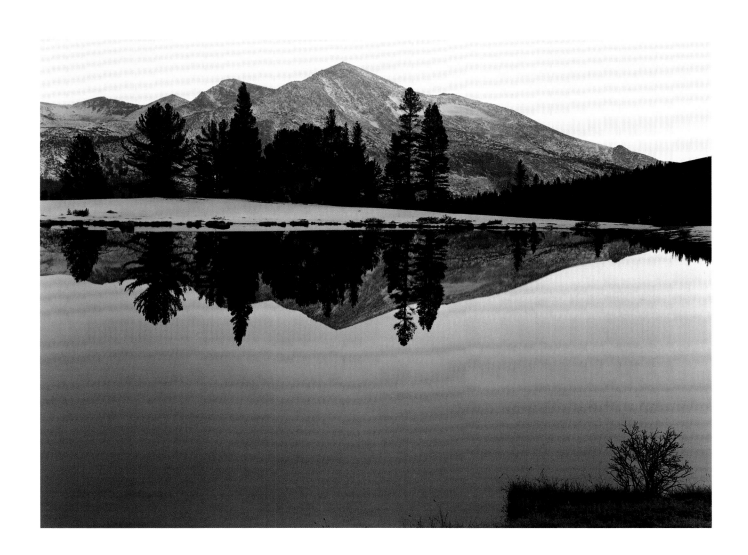

TUOLUMNE MEADOWS, CALIFORNIA 1984

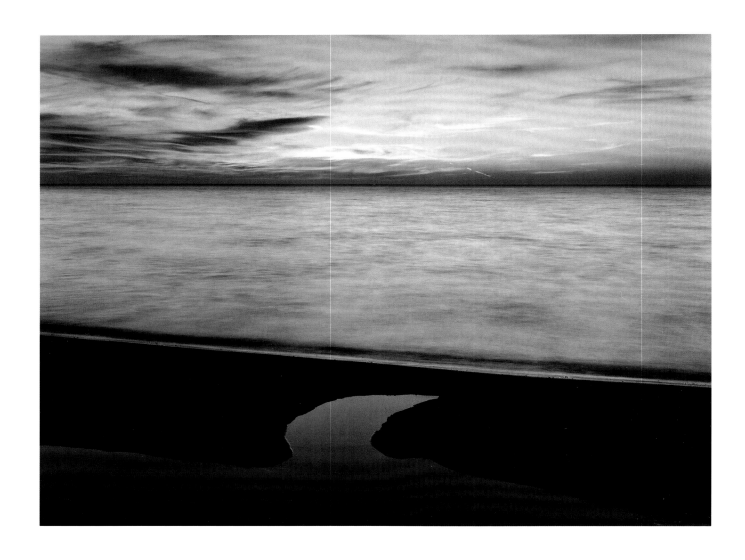

CROSS VILLAGE, MICHIGAN 1995

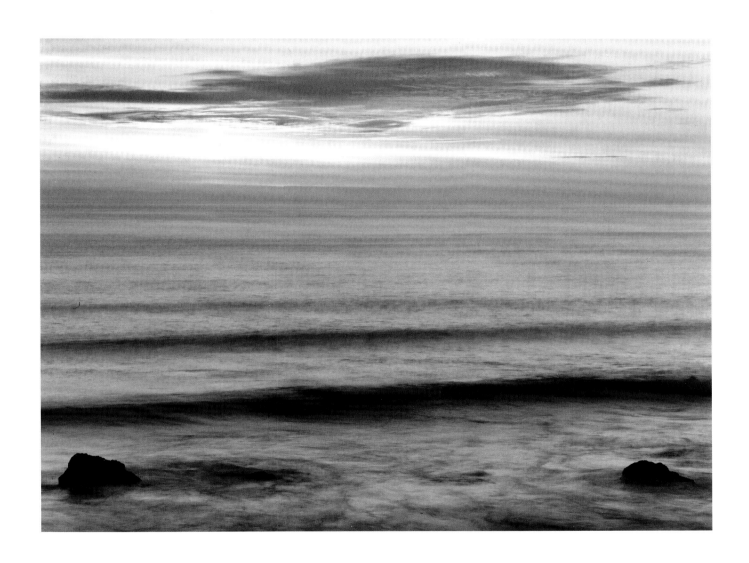

CAPE SEBASTIAN, CALIFORNIA 1997

I became aware of the photography of David Lubbers in 1984, when he contacted me and said he would like to show me recent work he had made in the Four Corners region of the Southwest. During a long-distance call, he explained that he was from Michigan but traveled frequently. He said he worked more or less in the tradition of "straight" landscape photography. My mind raced ahead of his words, and I could see print after print of sunlit mesas and rolling clouds. In amazing detail I could envision the rocky walls of the Canyon de Chelly rendered in delicate tones, stretching in the distance to a thin horizon. It was not too difficult a vision to call up because I had seen it all before. It was as if every aspiring photographer east of the Rockies had had a revelation after discovering their first book of Ansel Adams' photographs made in the great American West. They were inspired to go there too, believing that what they would photograph in the same locations would be different. Many of them had brought the results to me in the hope that I could sell their work. To my great surprise and relief, David's photographs were different. Like all true artists (as opposed to photographers striving to be recognized as artists), David had used his medium to make visible a very personal interpretation of the world that he was exploring. It is that exploration, and our friendship of fifteen years, that brings me to what I have to say about his work as it appears in this book.

As an artist, David has always acknowledged his genre to be the landscape, and he's never personally had a problem being identified with a long line of American landscape photographers. Ansel Adams always had a way with vistas—those kinds of landscapes that draw upon the relationship between the near and the far, revealing the all-encompassing beauty and splendor of the natural environment. On the other hand, photographer Paul Caponigro turned a mystical eye on his world, utilizing the atmospheric qualities of light and the studied contemplation of "place" to subtly reveal what he referred to as the "landscape behind the landscape." Then again there was Brett Weston, who could stand in front of the same scene as Adams and Caponigro and come away with a totally different, usually abstracted view of the landscape. All three of these artists (with whom I had the

pleasure to work) were at their zenith in the late twentieth century, and all three have had an amazing influence on an entire generation of photographers that came after them, David Lubbers included.

Undoubtedly, one does find the play of near and far perspective in many of David's images: take, for instance, two photographs like "Wawa, Canada" (pl. 5) and "Epoufette, Michigan" (pl. 6). That play of perspectives is repeated in "Bass Harbor, Maine" (pl. 29) and "Nazlini Badlands, New Mexico" (pl. 30). You can also sense the subtle contemplation of the landscape in "Workum, Netherlands" (pl. 3) and "Seney, Michigan" (pl. 4). Abstraction is undeniable in photographs like "Canyonlands National Park, Utah" (pl. 39) and "Isle Royale, Michigan" (pl. 40). It is a testament to David's work, however, that I have never looked at any of it and said, "That reminds me of a photograph of Ansel's or Brett's picture of such-and-such." In fact, the highest compliment I can give his work is to say that it is the product of a singular and consistent vision, and I have always believed that.

I have also always believed in what I call "the persistence of vision." This is something that can be detected only over an extended period of time; in my opinion, it identifies a photographer's understanding of his medium. I have had the opportunity to recognize this in David's photographs by comparing them over the years, and the concept is illustrated perfectly in the pairing of images in this book.

Consider for a moment that if you were to stand in a certain place and look around until your eyes settled on a particular point, you would in essence be framing a scene in much the same way a photographer selects what he sees within the borders of his viewfinder. If you then searched within your frame of sight, isolating shape and pattern, line and contrast, you would begin to see in a less literal, more abstract sense. You would be "seeing" in much the same way as a photographer who works in black and white: he must pre-visualize what he knows will appear on his negative. In time the photographer's intuition, born of experience, takes over to the degree that he can select his subject, isolate his impressions of it, and overlay the

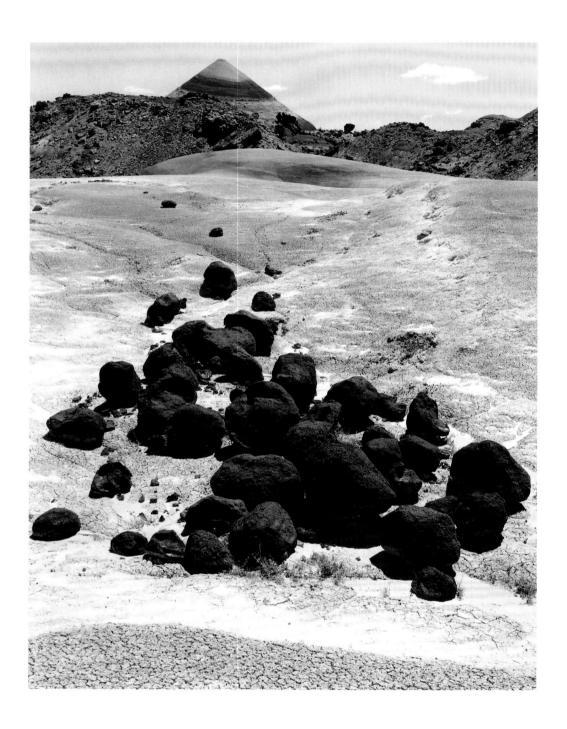

CAINSVILLE, UTAH 1987

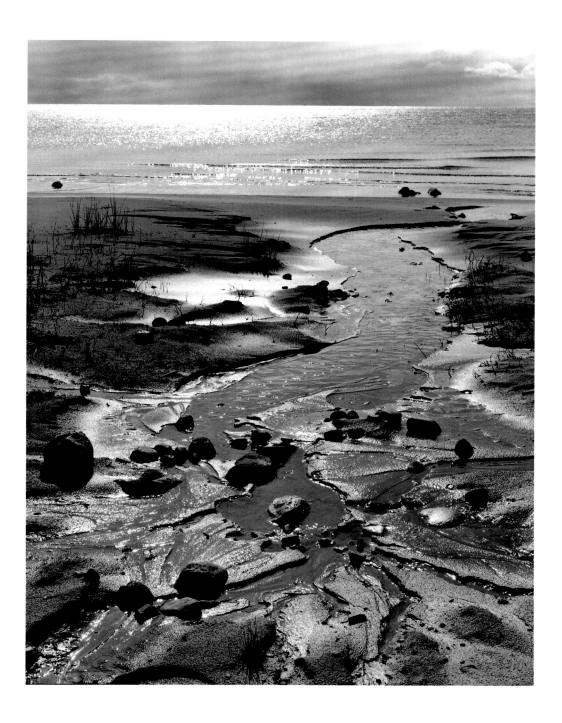

EPOUFETTE, MICHIGAN 1991

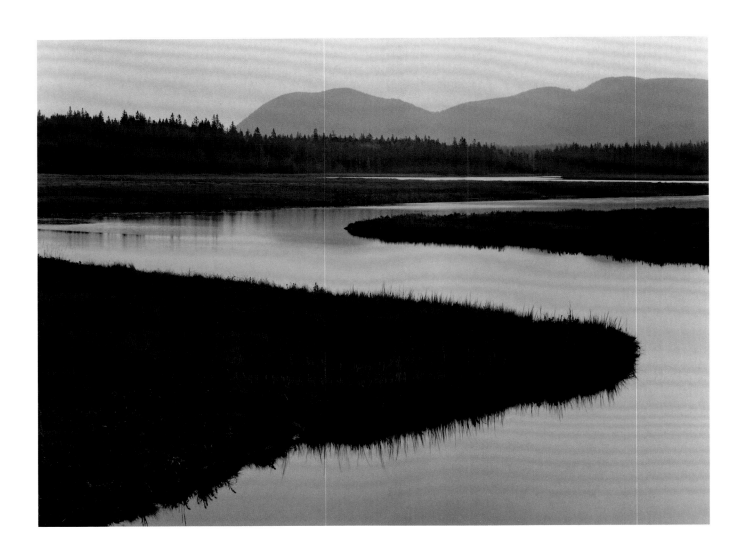

BASS HARBOR, MAINE 1994

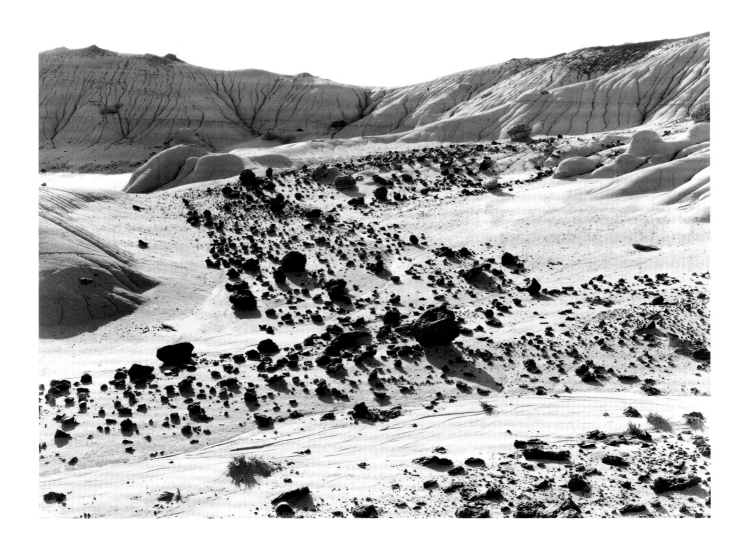

NAZLINI BADLANDS, NEW MEXICO 1992

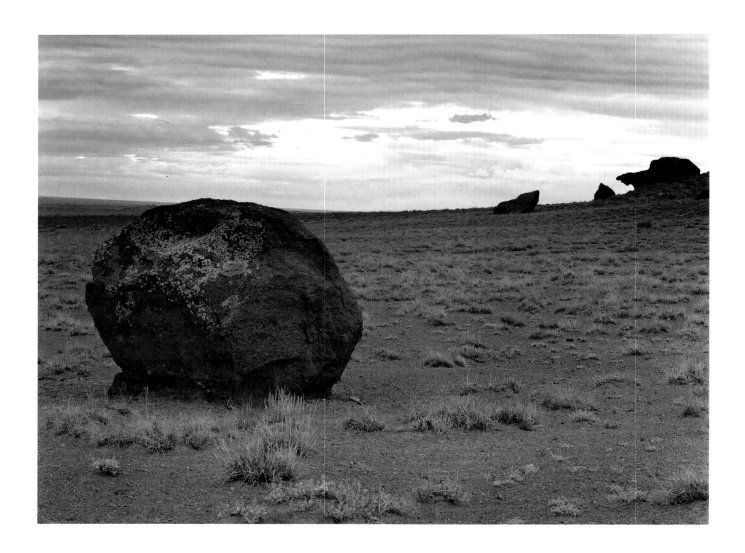

SHIPROCK, NEW MEXICO 1989

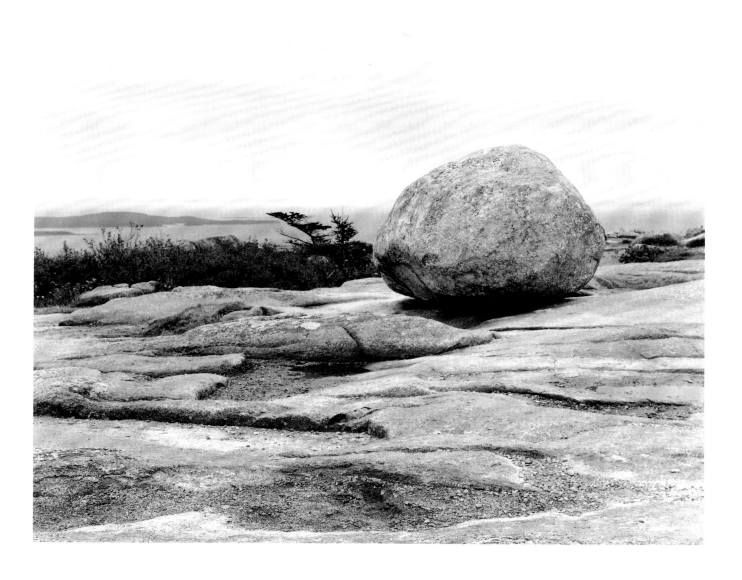

CADILLAC MOUNTAIN, MAINE 1994

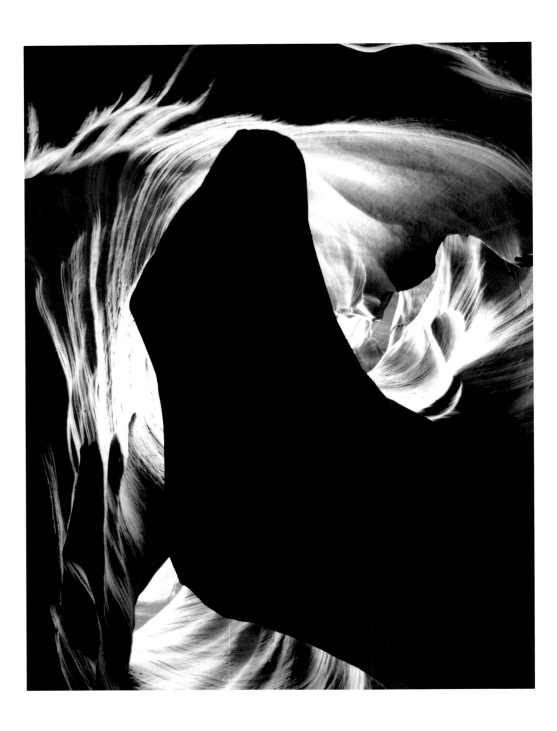

PAGE, ARIZONA 1985

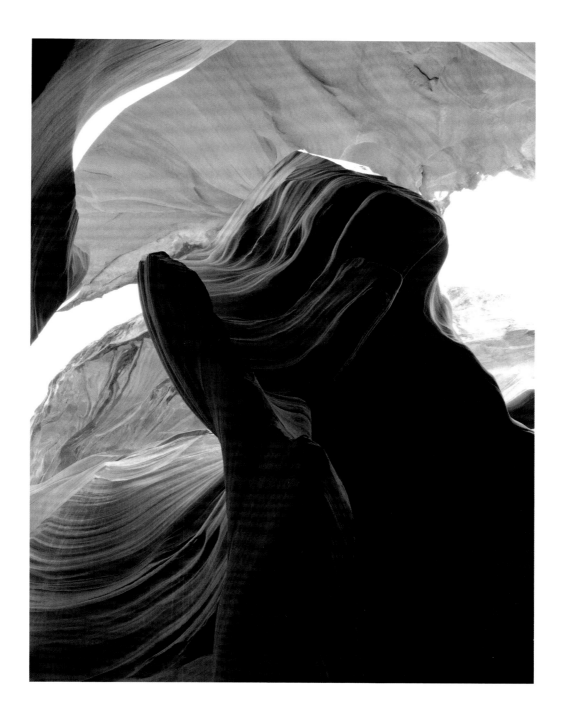

PAGE, ARIZONA 1991

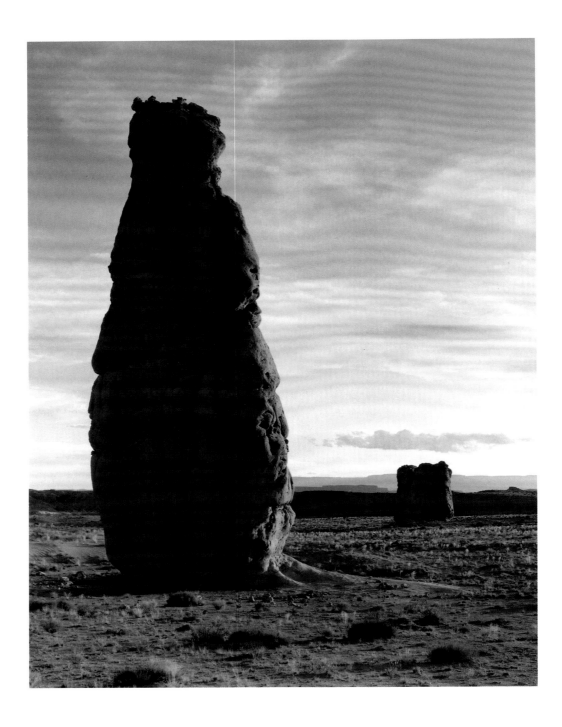

GOBLIN VALLEY, UTAH 1991

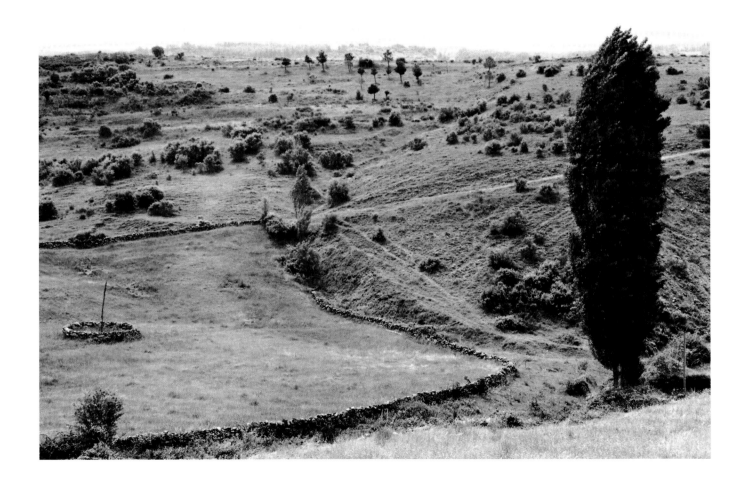

GUARDA, PORTUGAL 1985

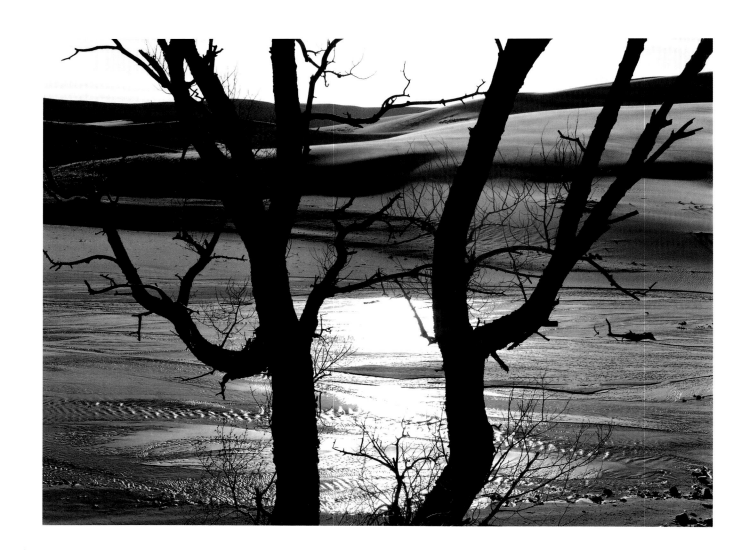

GREAT SAND DUNES NATIONAL MONUMENT, COLORADO 1992

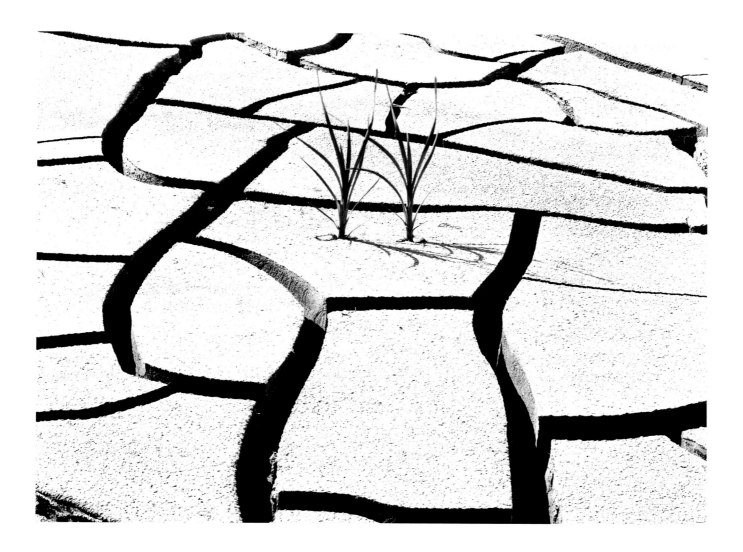

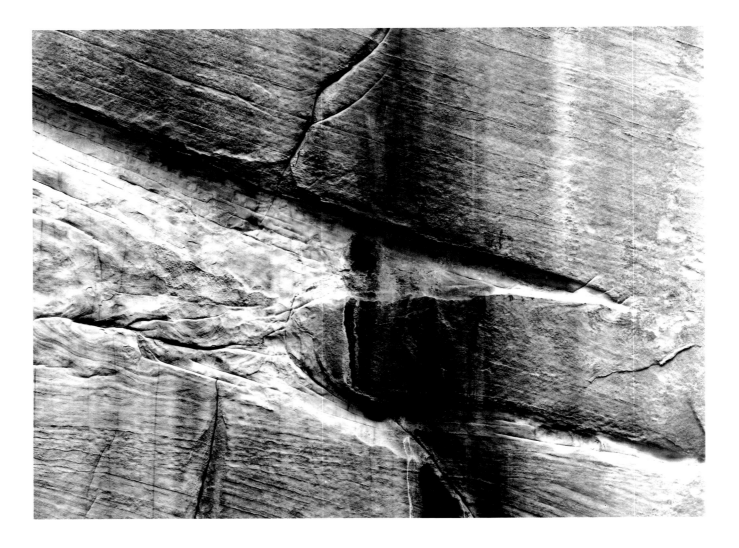

CANYONLANDS NATIONAL PARK, UTAH 1988

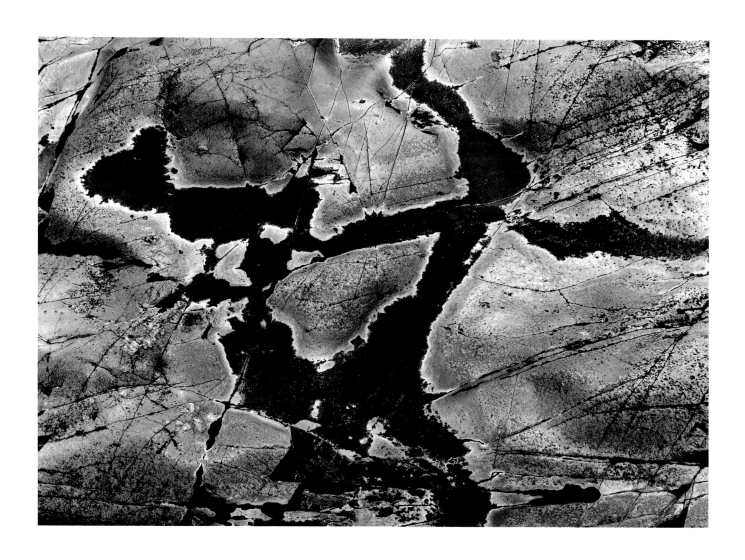

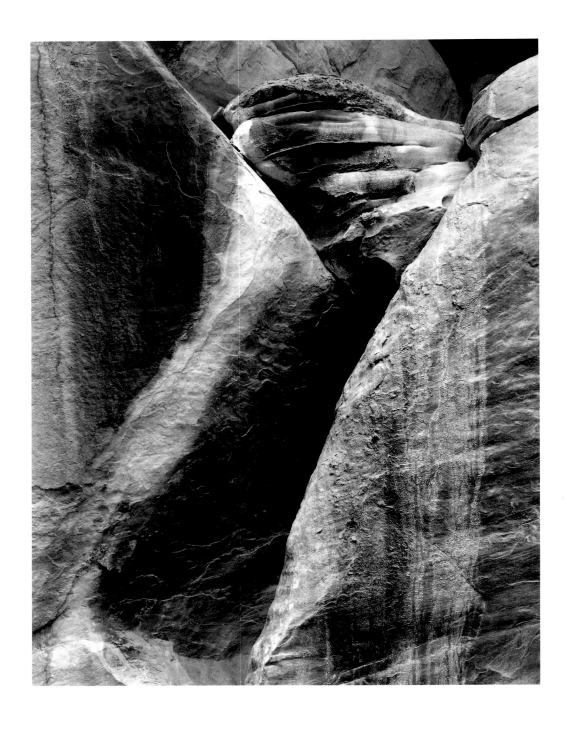

CANYONLANDS NATIONAL PARK, UTAH 1992

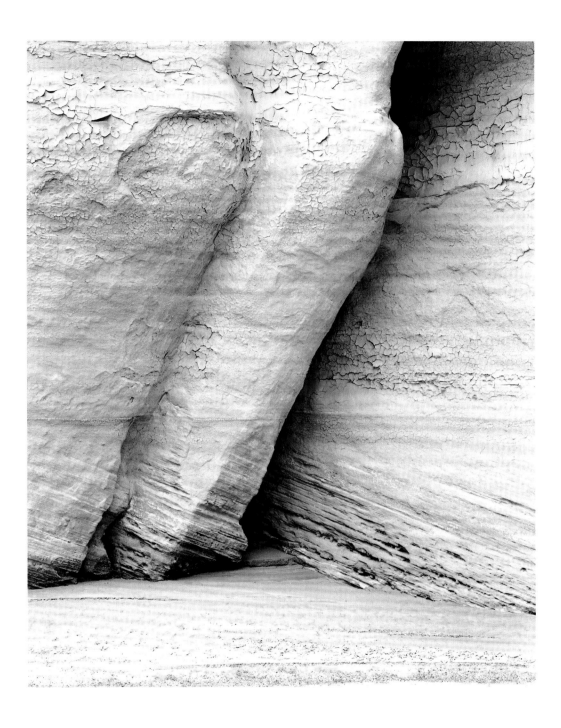

PARIA CANYON, UTAH 1991

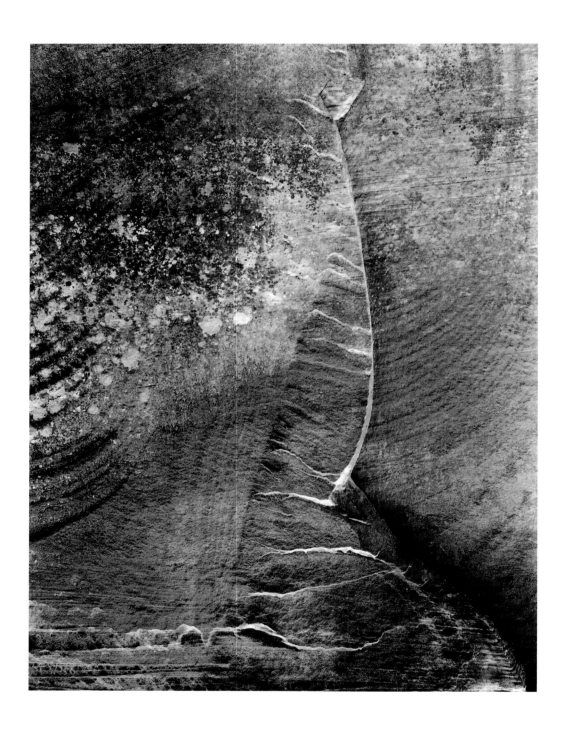

BUCKSKIN GULCH, UTAH 1985

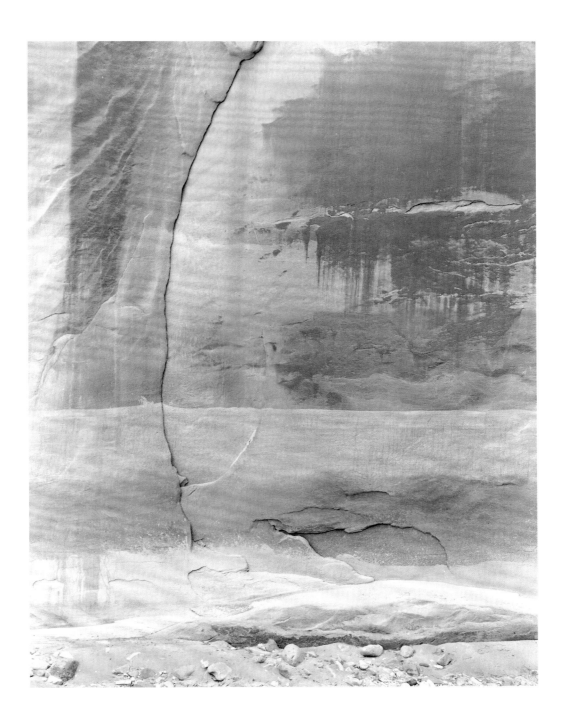

PARIA CANYON, UTAH 1985

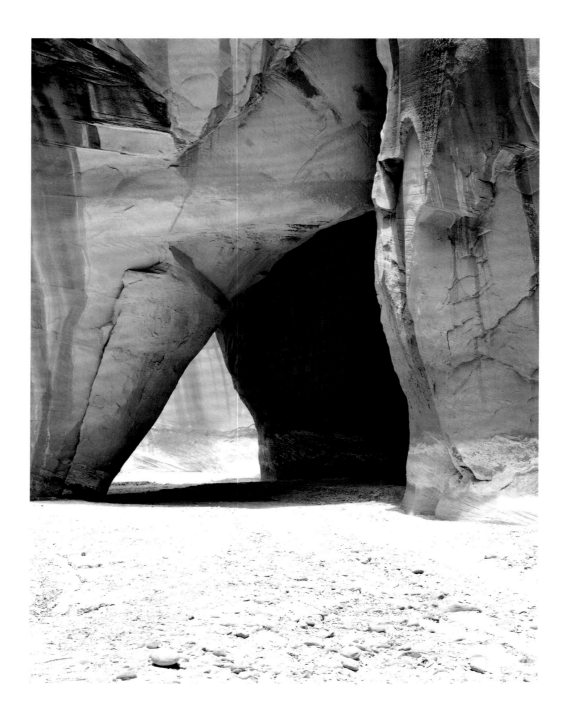

PARIA CANYON, UTAH 1985

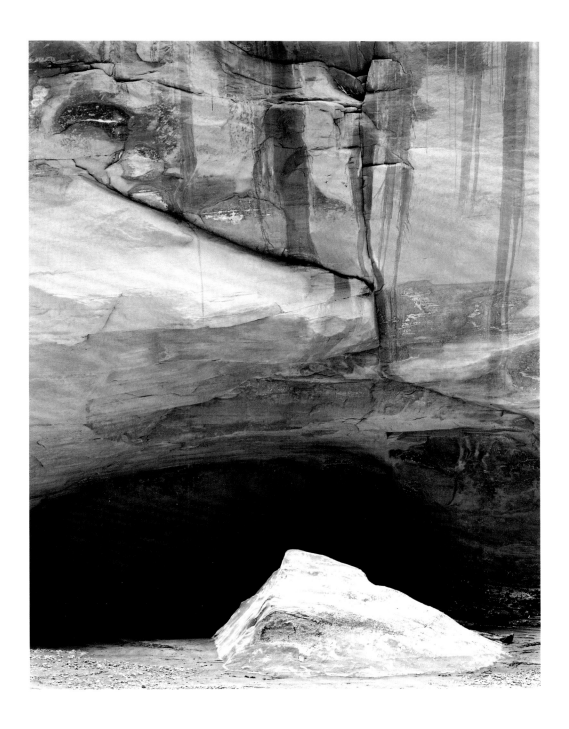

PARIA CANYON, UTAH 1985

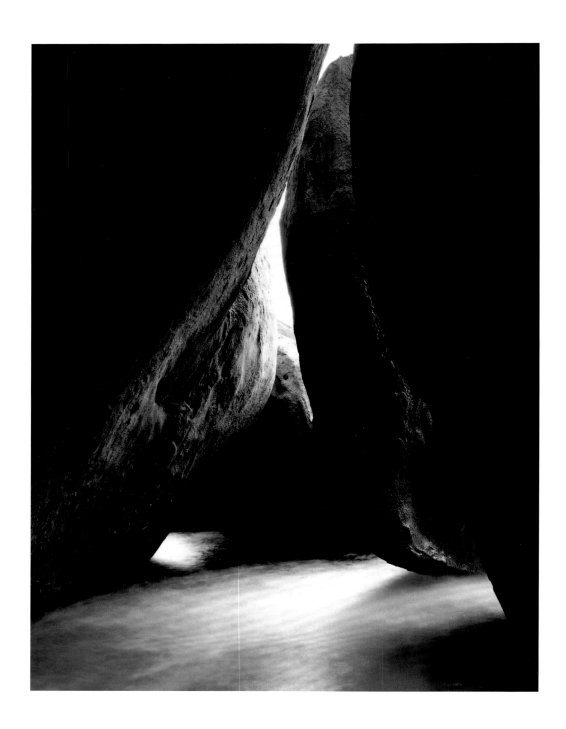

VIRGIN GORDA, BRITISH VIRGIN ISLANDS 1998

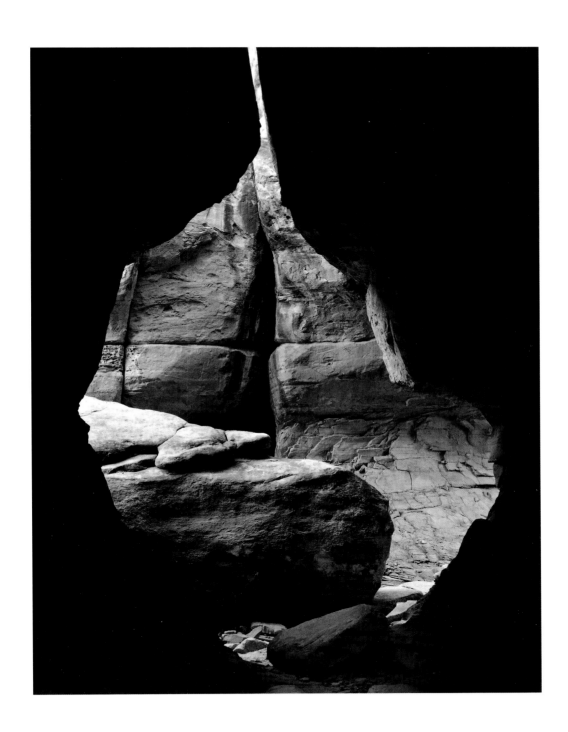

CANYONLANDS NATIONAL PARK, UTAH 1993

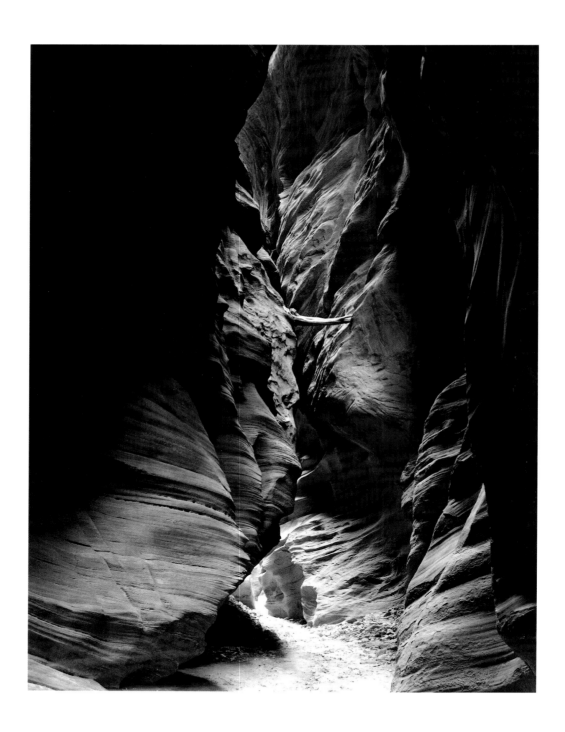

BUCKSKIN GULCH, UTAH 1992

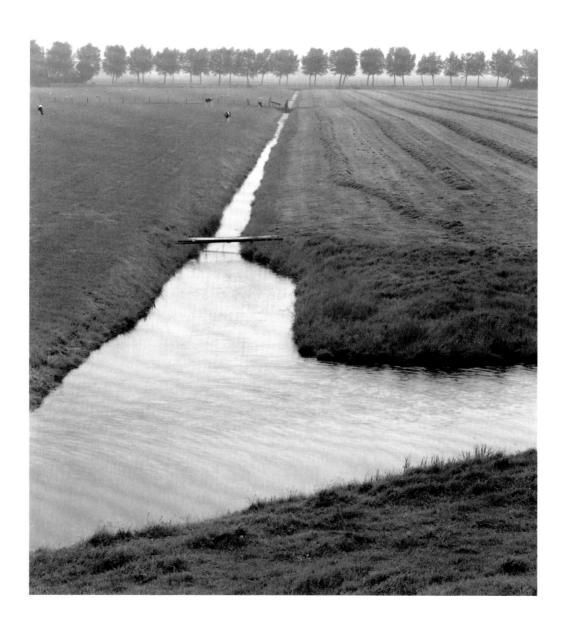

EDAM, NETHERLANDS 1998

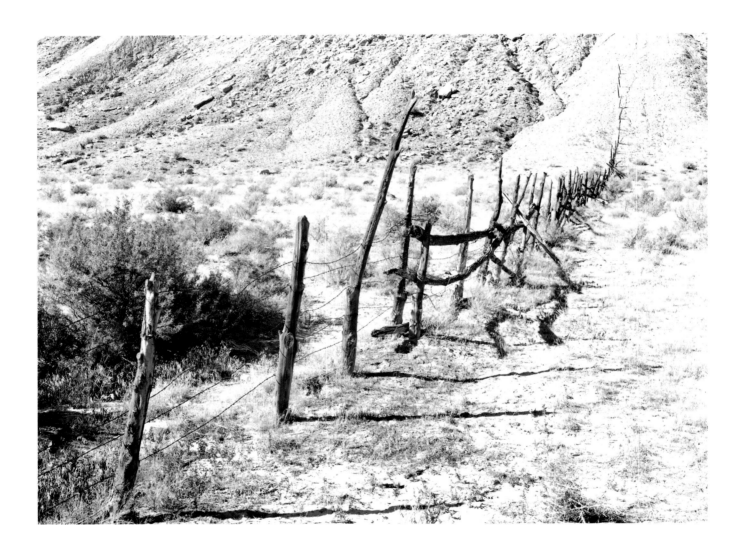

GLEN CANYON, UTAH 1986

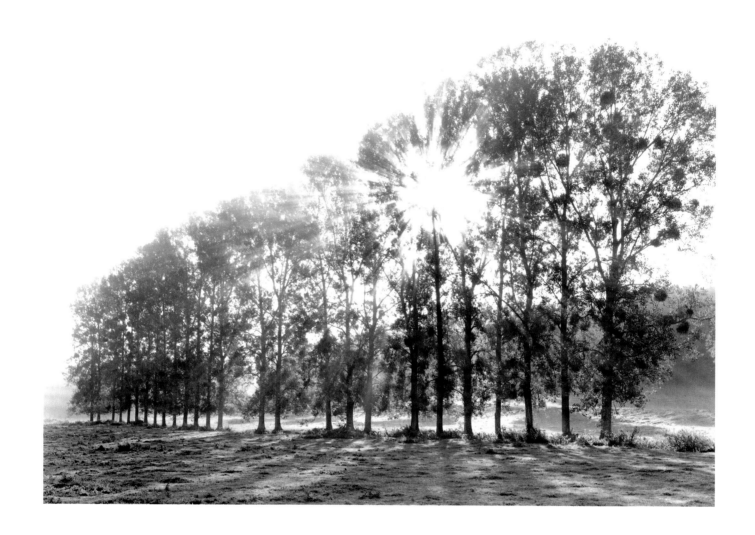

VÉZELAY, FRANCE 1997

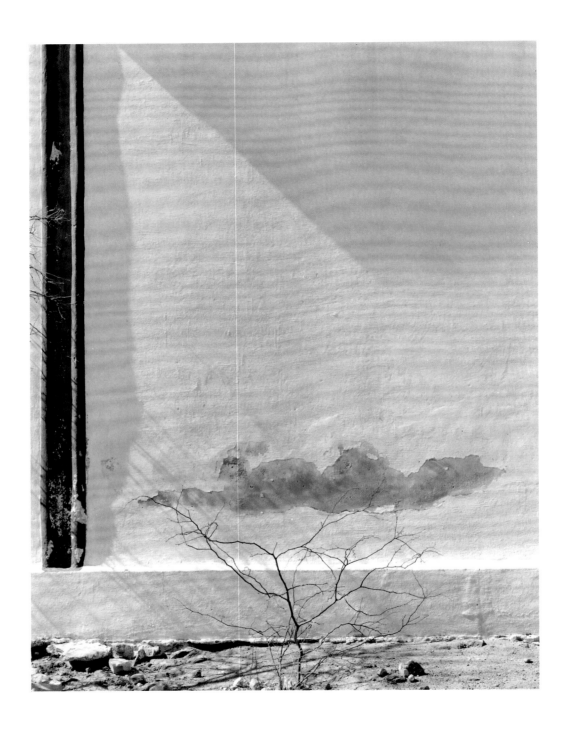

San Xavier, Arizona 1987

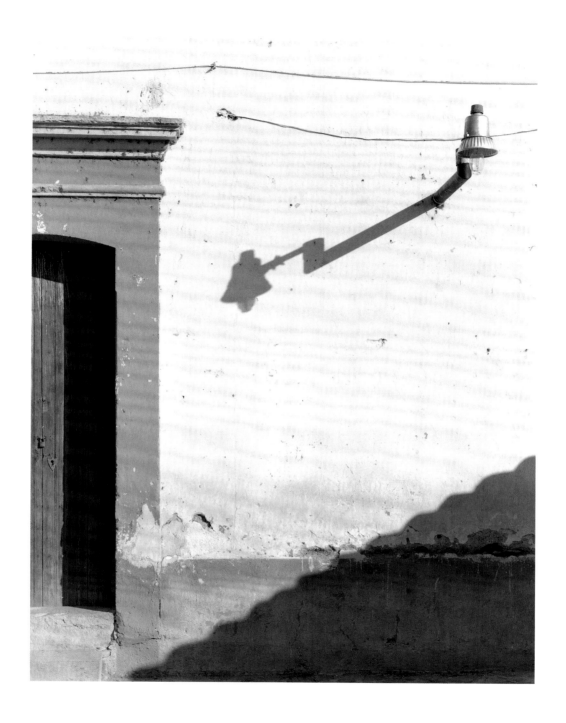

TEOTITLAN DEL VALLE, MEXICO 1994

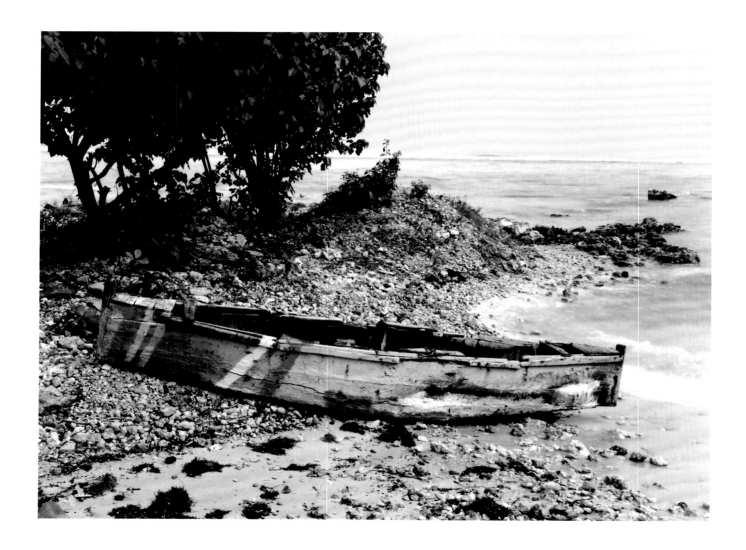

OCHO RIOS, JAMAICA 1996

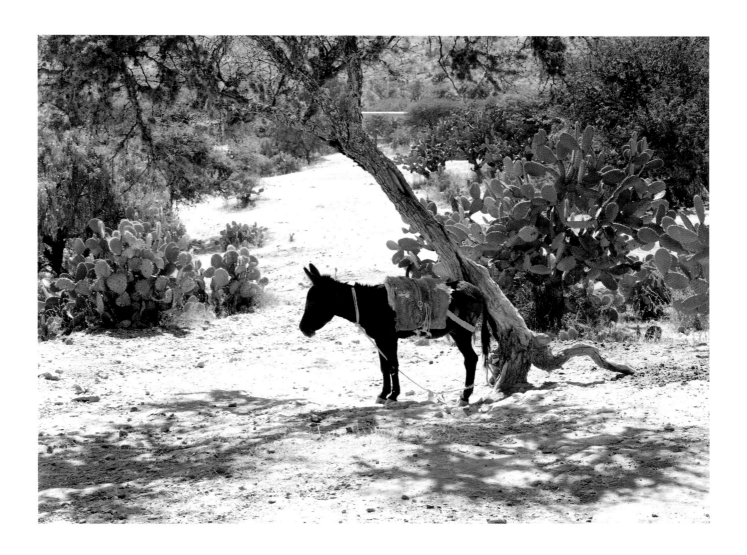

SONORA, MEXICO 1986

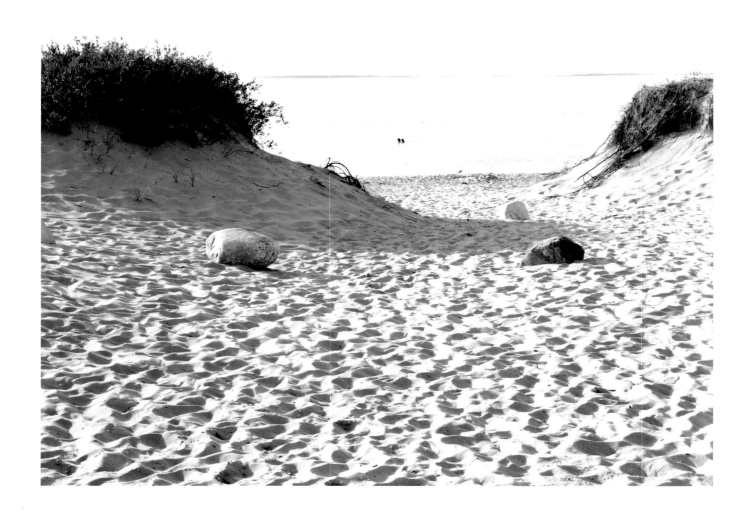

CROSS VILLAGE, MICHIGAN 1995

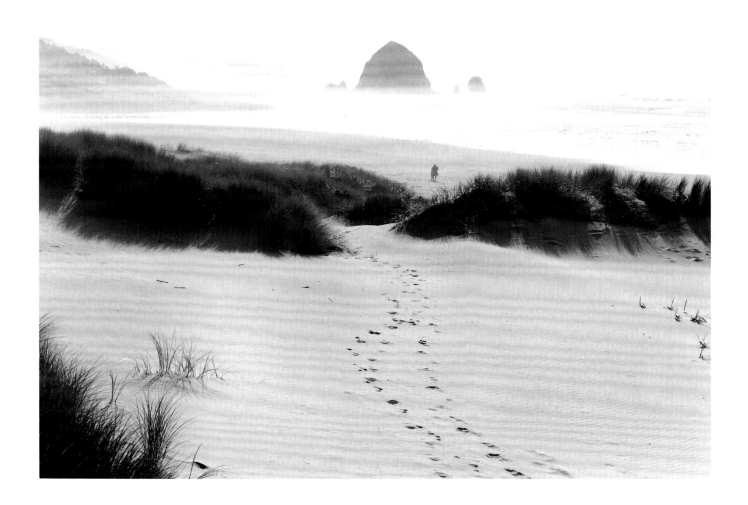

CANNON BEACH, OREGON 1997

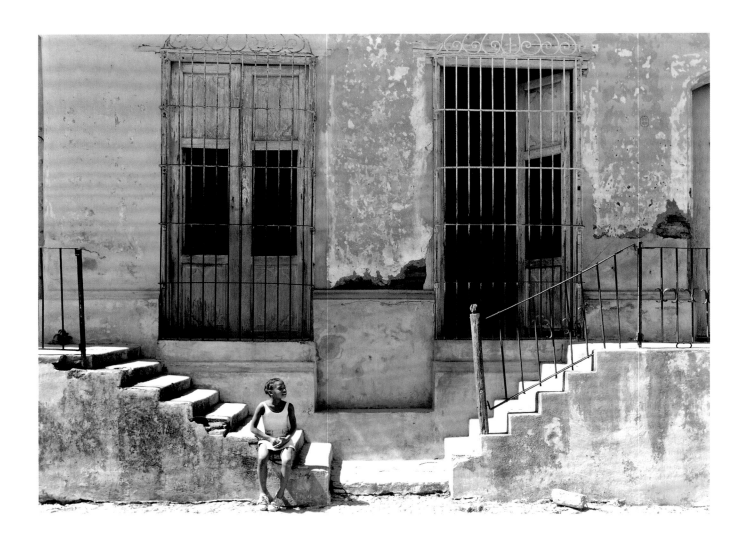

TRINIDAD, CUBA 1999

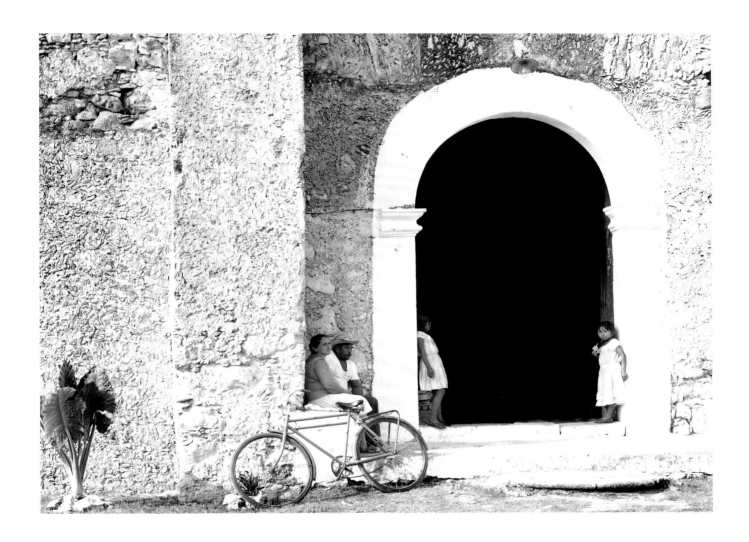

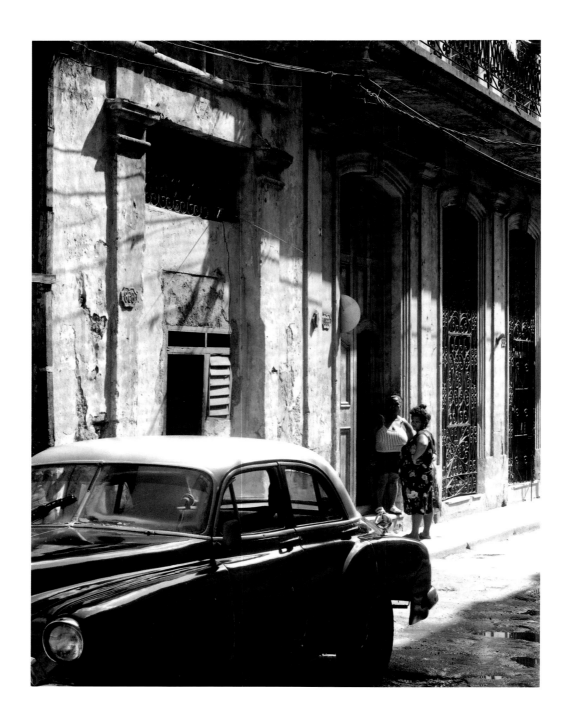

Havana, Cuba 1999

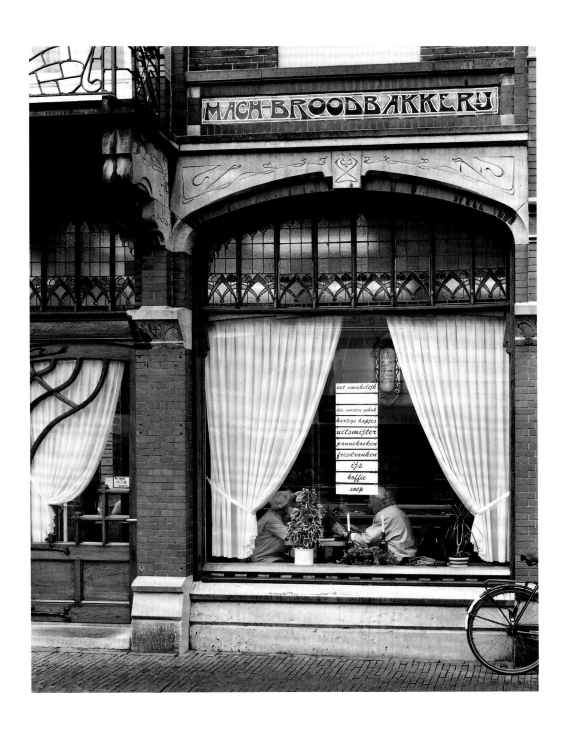

MACH·BROODBAKKERIJ

eet smakelijk

div soorten gebak
hartige hapjes
uitsmijter
pannekoeken
frisdranken
ijs
koffie
soep

KAMPEN, NETHERLANDS 1998

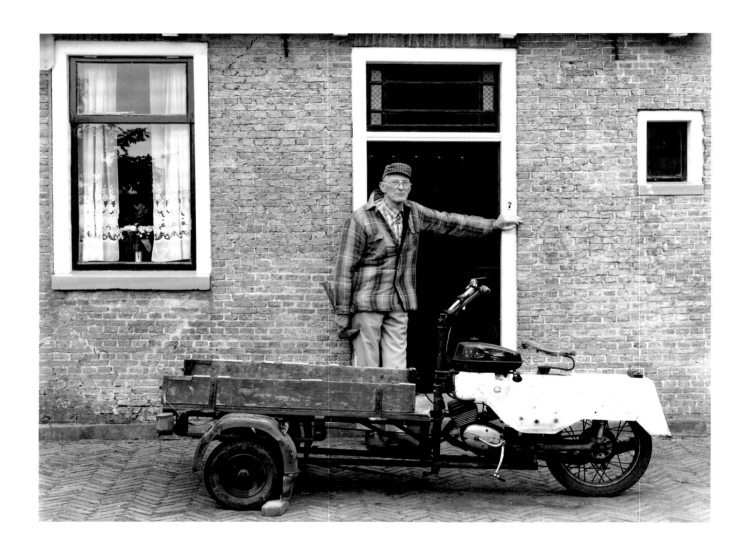

OUDEGA, NETHERLANDS 1998

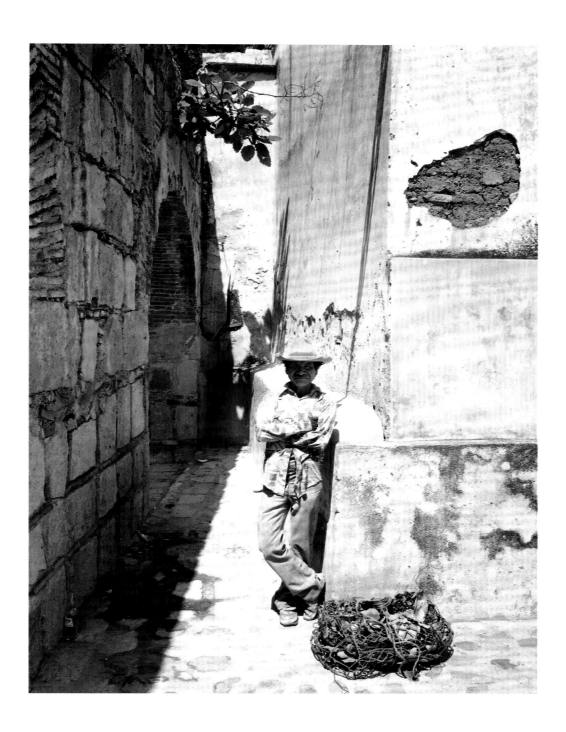

OAXACA, MEXICO 1989

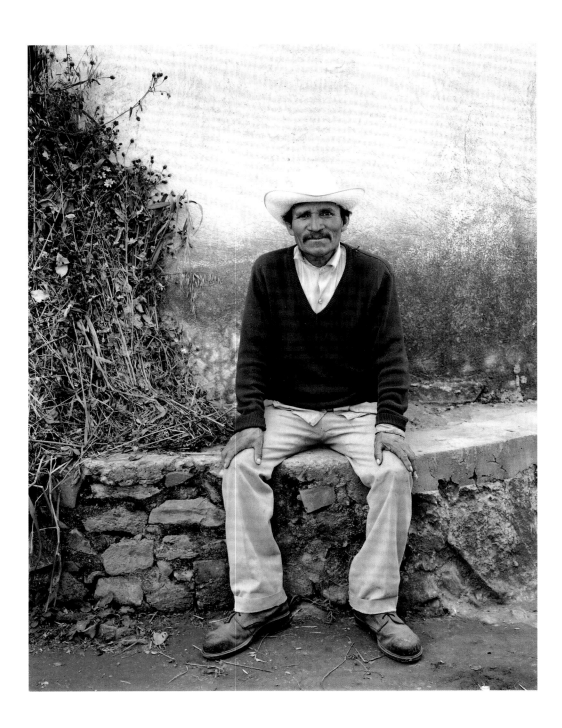

OAXACA, MEXICO 1989

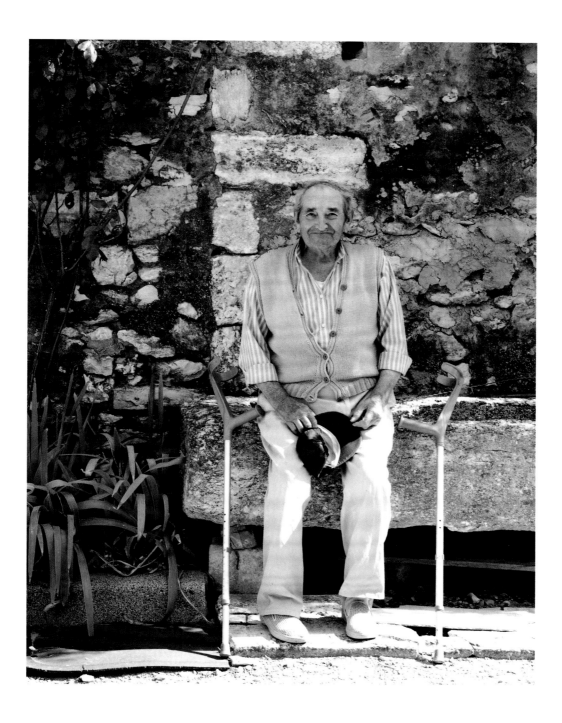

TARASCON, FRANCE 1999

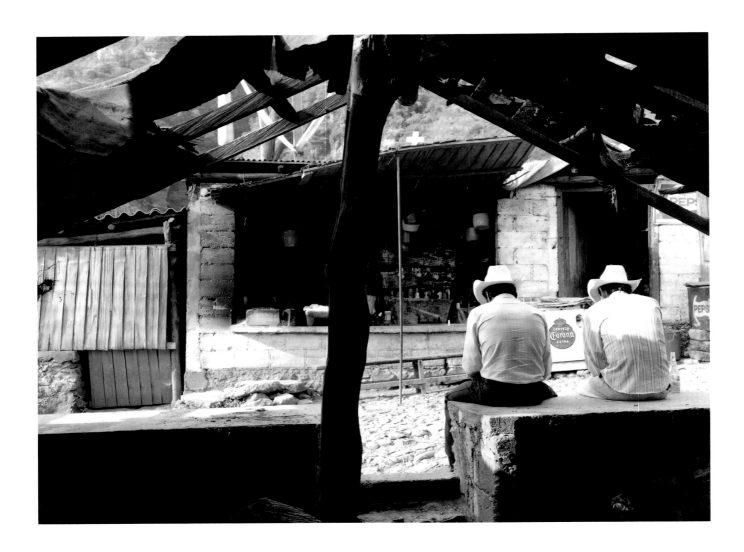

CHALMA, MEXICO 1989

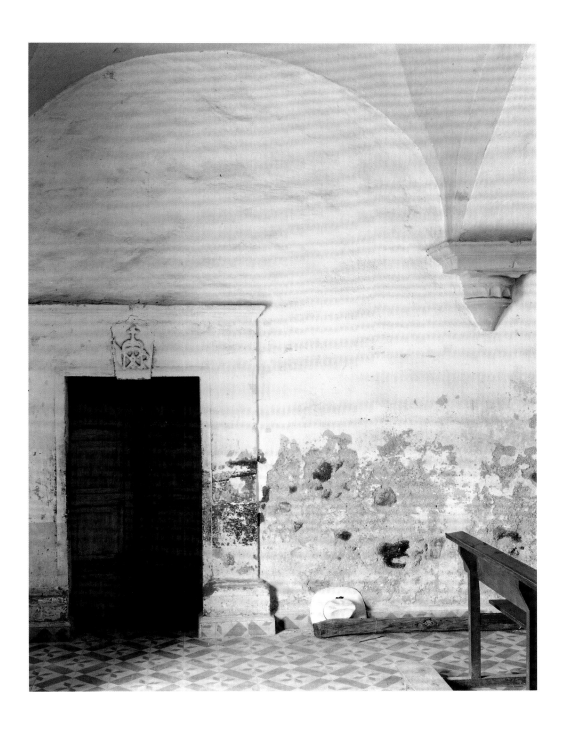

MALINALCO, MEXICO 1989

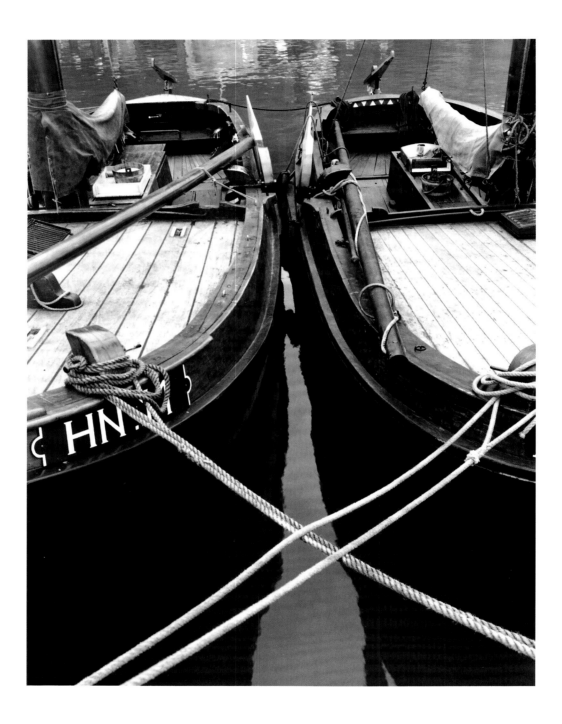

HOORN, NETHERLANDS 1998

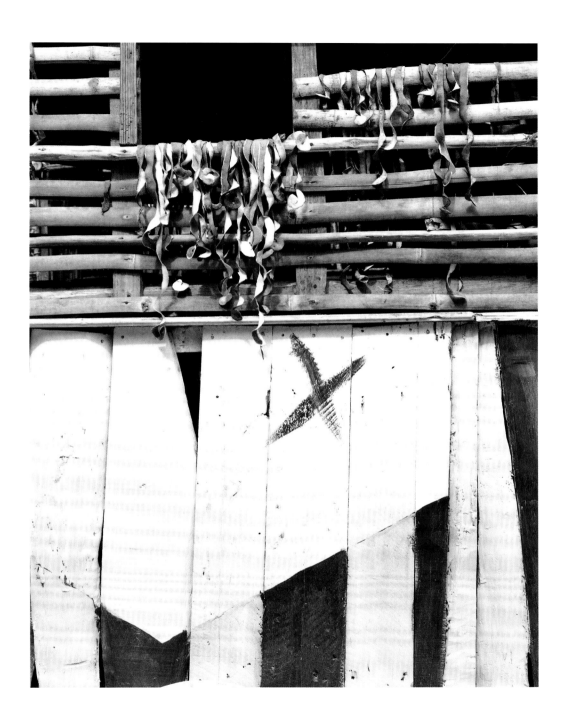

OCHO RIOS, JAMAICA 1996

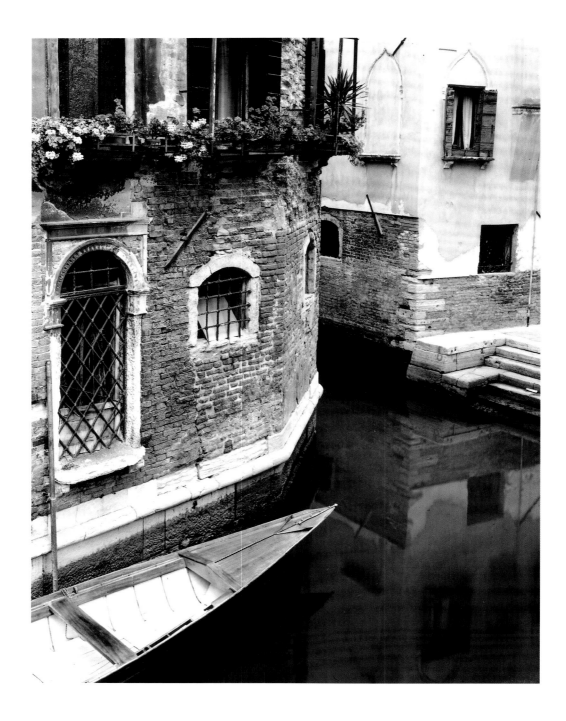

VENICE, ITALY 1996

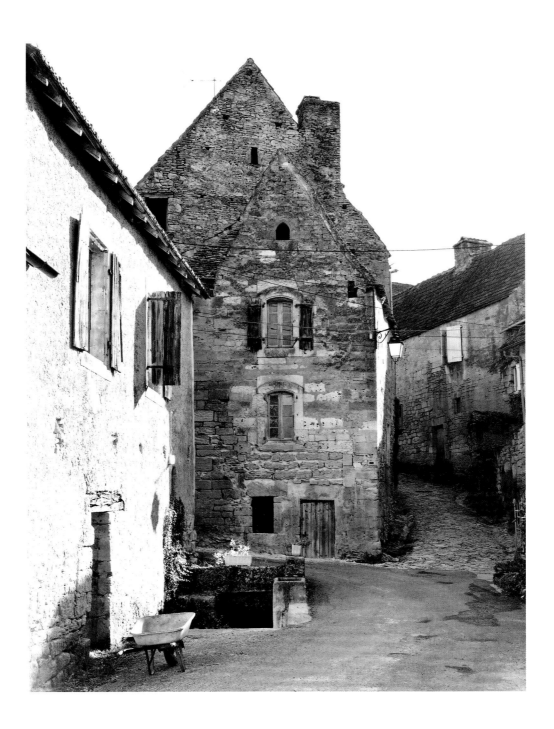

MEYRALS, FRANCE 1997

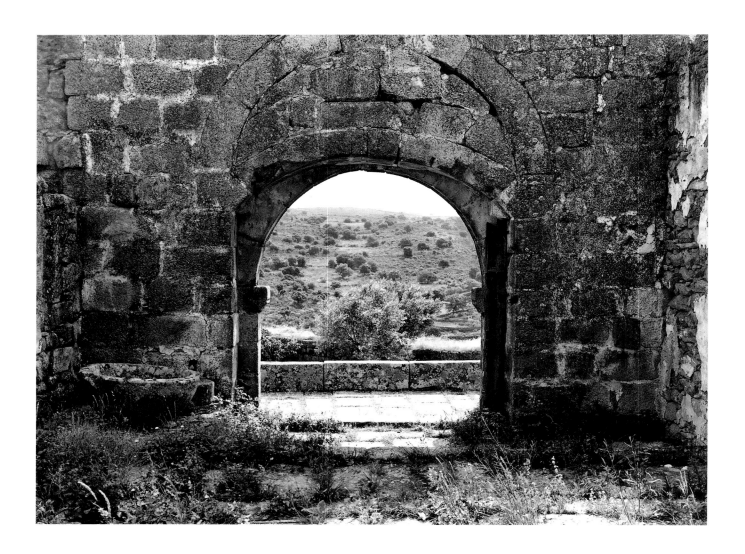

Sequeros, Spain 1987

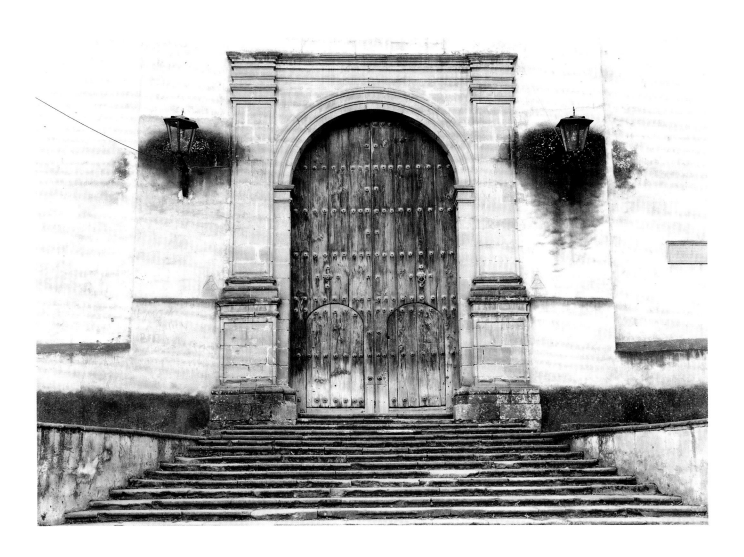

PÁTZCUARO, MEXICO 1988

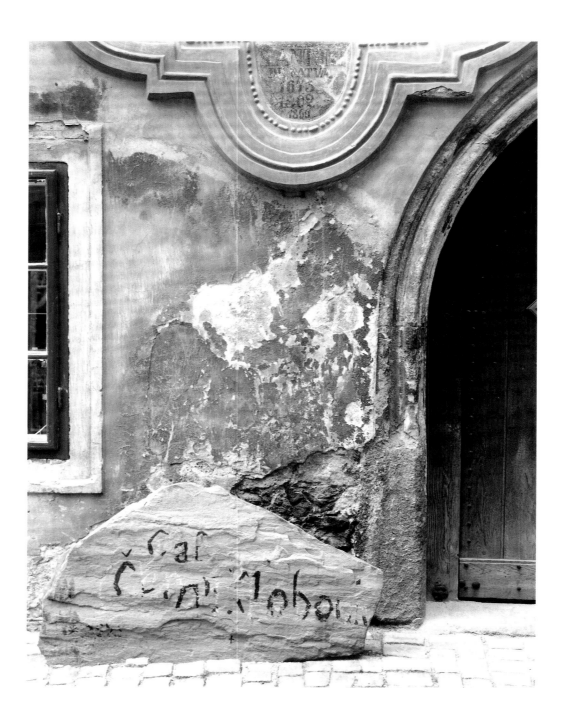

ČESKÝ KRUMLOV, CZECHOSLOVAKIA 1996

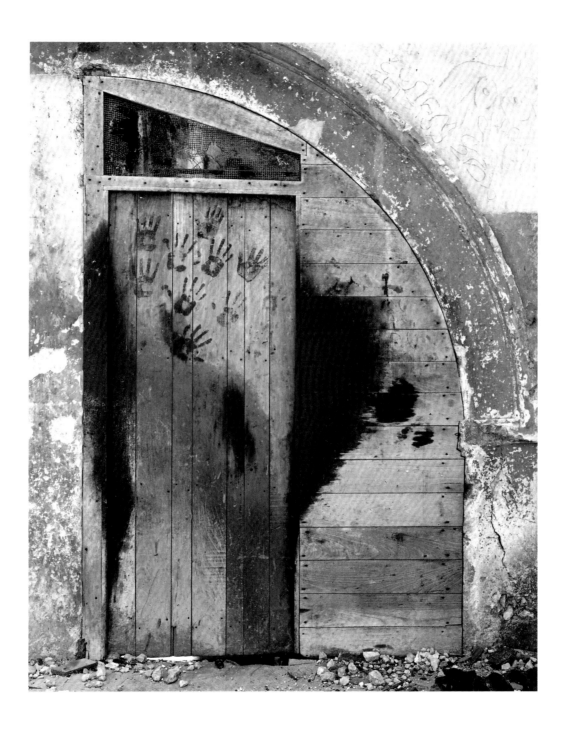

KANTUNIL, MEXICO 1986

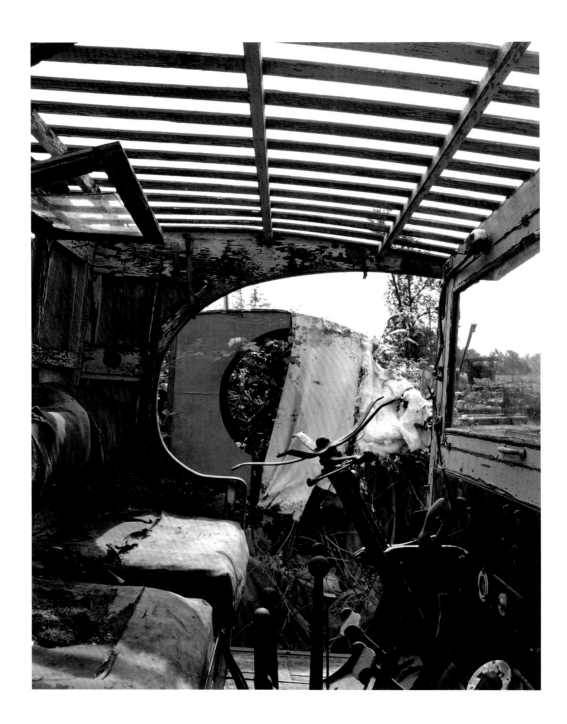

MAD RIVER, CALIFORNIA 1988

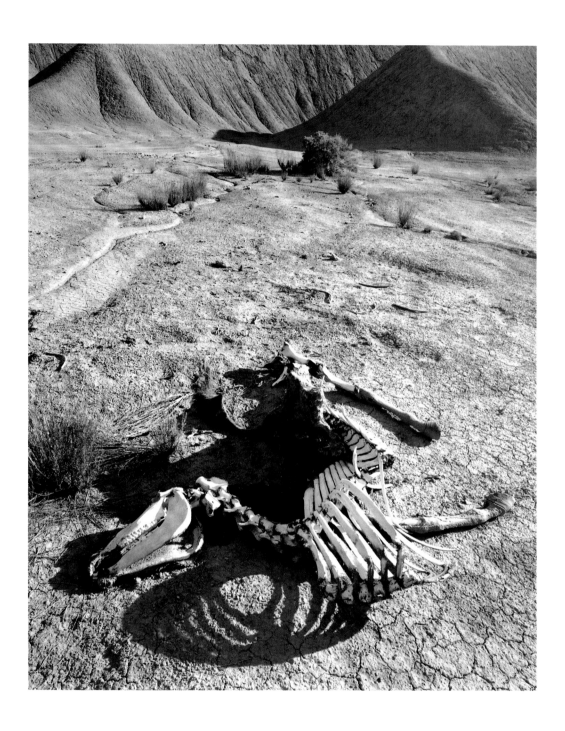

CAINSVILLE, UTAH 1991

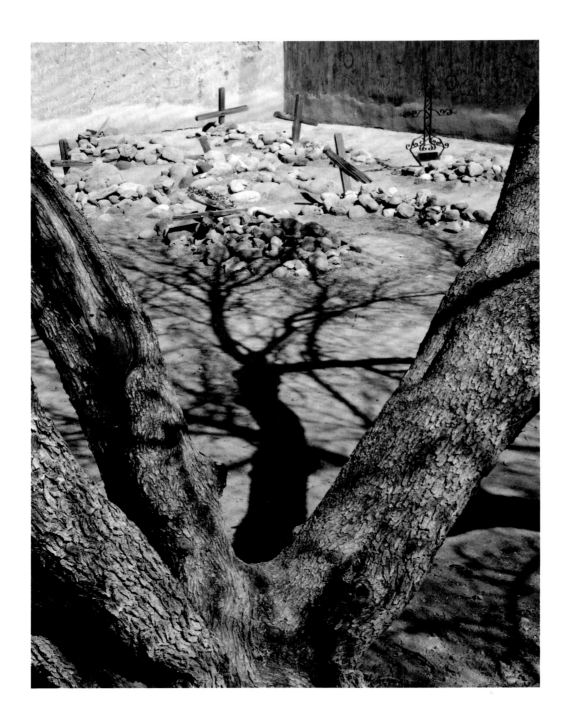

TUMACACORI, ARIZONA 1993

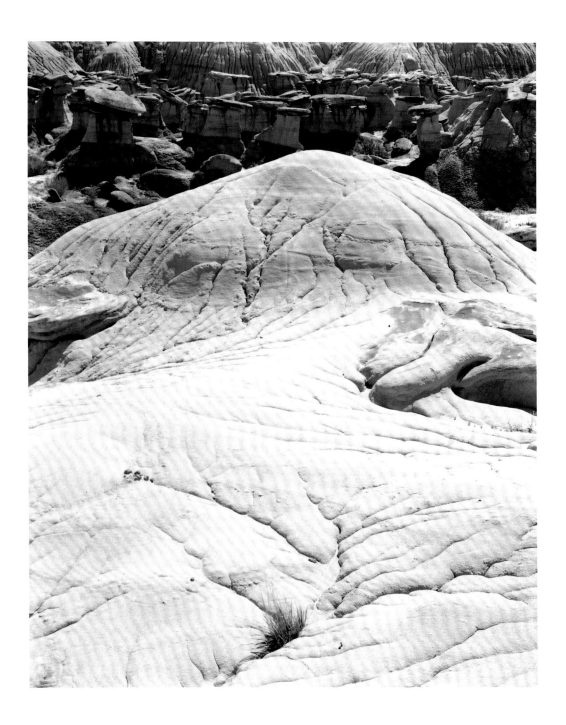

NAZLINI BADLANDS, NEW MEXICO 1991

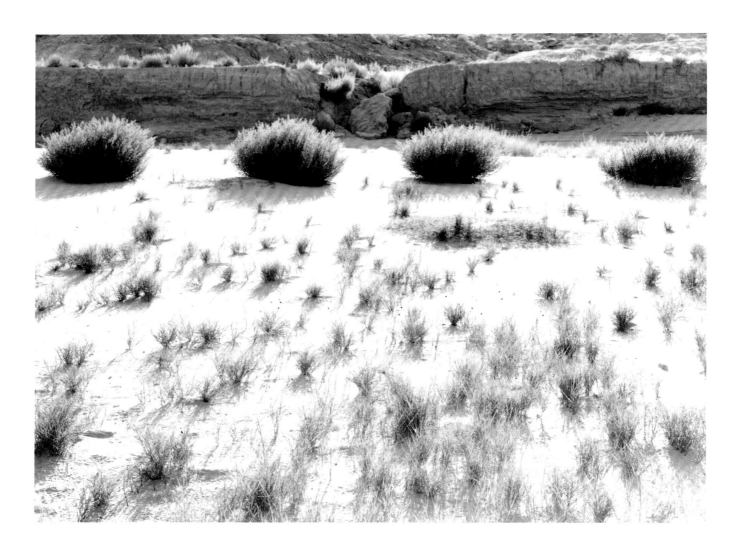

BLUFF, UTAH 1987

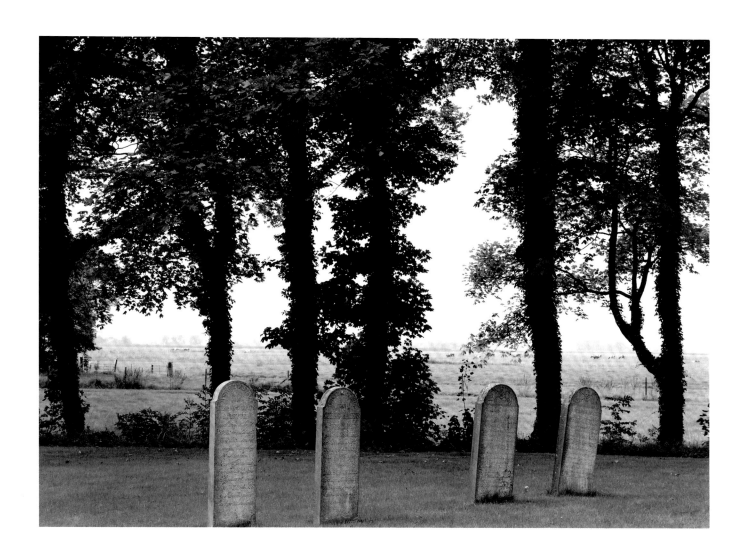

GARMERWOLDE, NETHERLANDS 1998

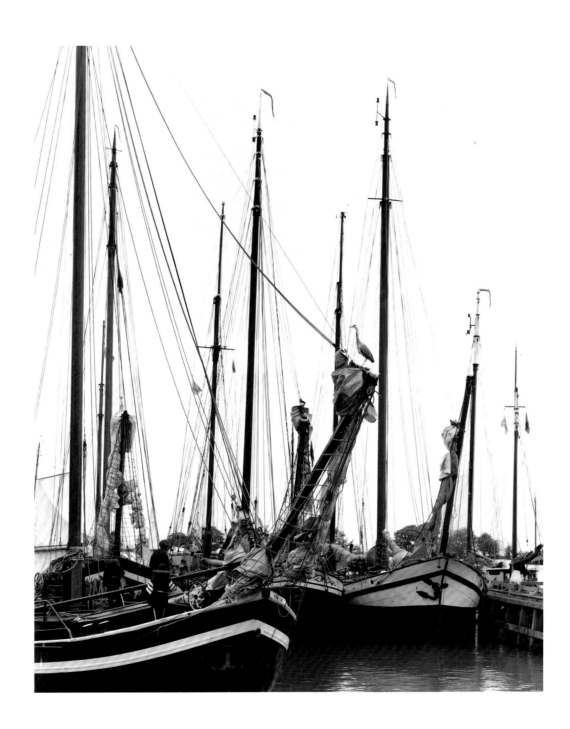

HOORN, NETHERLANDS 1998

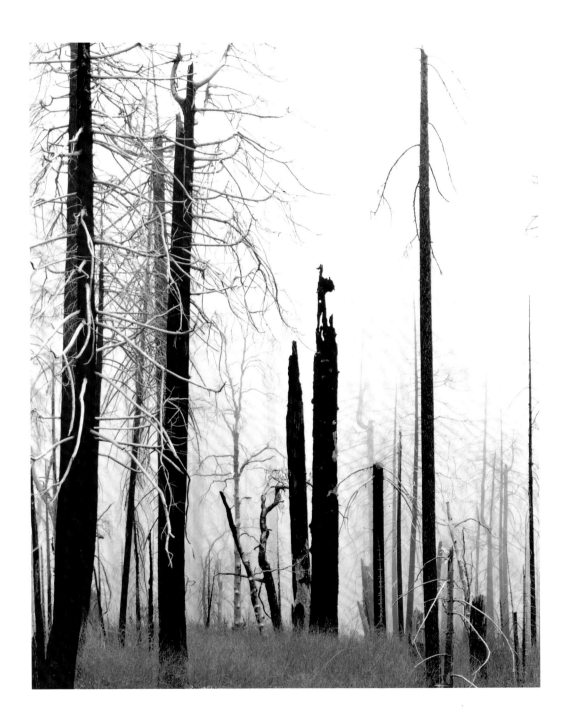

WAWONA, CALIFORNIA 1993

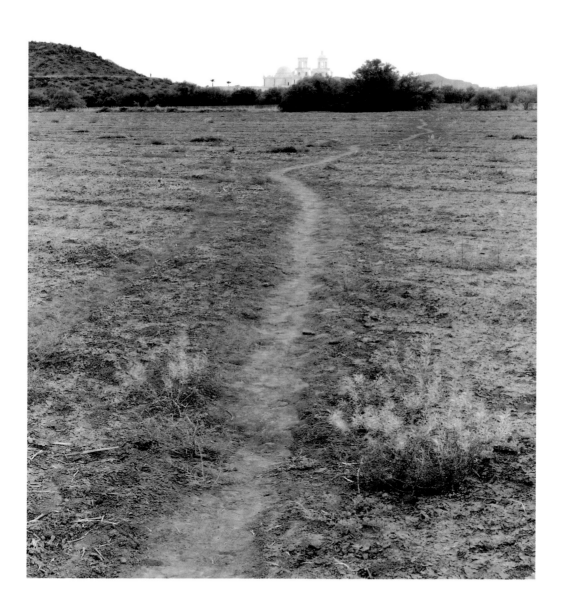

SAN XAVIER, ARIZONA 1993

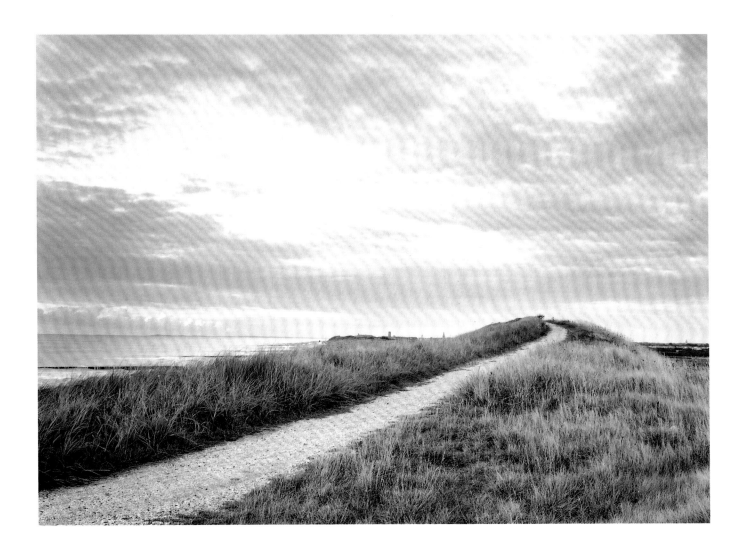

WESTKAPELLE, NETHERLANDS 1998

Index of Photograph Titles